Light and shadows

Light determines the volume, texture, colour and spatial location of all the elements in the universe, and it gives a each of them a particular form. Shadows are parasites of light; without it, they would not exist.

Credits

EXPLORING BLACK AND WHITE
Drawing and Painting Techniques

© 2019 Promopress Editions
© Texts and illustrations: Víctor Escandell
www.victorescandell.com
Photos and QR videos: Alehop
Editing and coordination: Rebeka Elizegi
Revision of texts: Montse Borràs
Design and layout: Alehop

ISBN: 978-84-16851-82-9
D.L.: B 9358-2018

Promopress is a brand of:
Promotora de Prensa Internacional S.A.
C/ Ausiàs March 124
08013 Barcelona, Spain
Tel: 0034 93 245 14 64
Fax: 0034 93 265 48 83
email: info@promopress.es
www.promopresseditions.com
Facebook: Promopress Editions
Twitter: Promopress Editions@PromopressEd

With the support of:

G CONSELLERIA
O CULTURA,
I PARTICIPACIÓ
B I ESPORTS
/

institut d'estudis
baleàrics

Printed in China

Exploring
Black
&White

Drawing and Painting Techniques

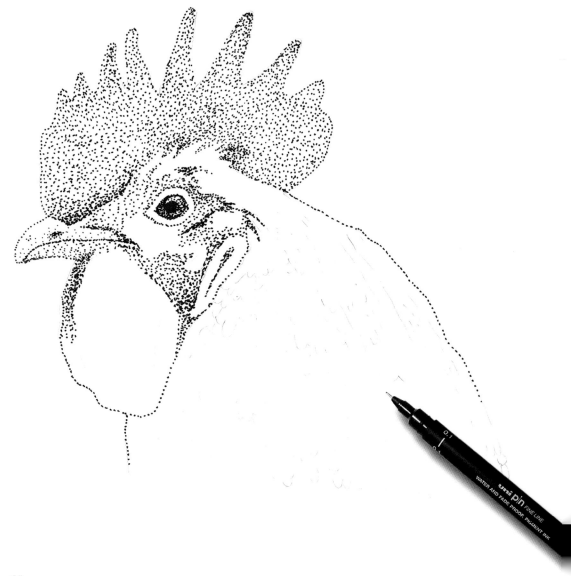

PROMOPRESS 11

Víctor Escandell

Contents

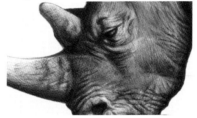
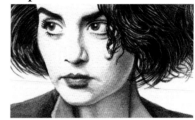

Manifesting creativity

Ever since humans first manifested their creativity to reflect their concerns, their mood, their beliefs and their sense of beauty, they have discovered and used different materials that have served as tools for drawing, painting or sculpting.

Prologue

A perfect pairing

Ever since it has been in development, this book's main objective has been to shed light on the artistic world created by a pairing of two things that are radically antagonistic yet perfectly matched: black and white.

This achromatic coupling has for centuries deservedly had a monopoly on elegance and style. But this should not come as a surprise, as we owe a great deal to it: since 1450 and the appearance of the *Gutenberg* press, humankind has been reading books printed in black on white. In 1824, it admired the first photographs by *Niépce*; in 1895, it fell in love with the *Lumière* brothers' first film; and in 1937 it gazed in astonishment at the image of war presented by *Picasso's Guernica*, one of the most famous paintings in history. Much of our history has happened in black and white, and the cultural imprint that the pairing has left on us has seeped into the very marrow of our bones.

White is light, and an absence of colour, and so it is an achromatic value.

Cultural references

What is beauty?
This is a question that philosophers have ceaselessly asked over the course of history, but it has always ended up being the subject of interminable discussions. "Beauty" is as subjective a term as "love" or "happiness," ideas that humankind has always been preoccupied with and that for some are the reason for existence.

As I have said, it has not proved possible to define exactly what beauty is, but what we do know is that the power of abstraction that lies in black and white when they are placed together is almost Arcadian.

Black is a chromatic value, since it is the result of when cyan, magenta and yellow are superposed, with this mixture absorbing light waves.

The abstraction of colourlessness

The verb "abstract" has been defined as, *"Separating by means of an intellectual operation a trait or a quality of something to analyse it in isolation or to consider it in its pure essence or notion."*

In my understanding, this is exactly what black and white contribute to reality.

Black and white in nature

Nature itself is also filled with iconic black and white reference points. Consider all the beautiful animals that are purely black and white or whose markings are one or both of these: the zebra, the cow, the orca, the magpie, the polar bear and the black panther are good examples of natural achromatic binarism.

Cultural significance

White

In Western society, white represents innocence and purity. It has been the traditional colour of these things since the Victorian era, and in many cultures white represents hope for the future. In Asian countries, it may also represent death, bereavement, virginity, purity, humility, youth or eternal peace, among other concepts.

Black

This is the total absence of light. Black symbolizes strength and stability. In Western culture, it has more negative connotations than it does positive ones. It is the symbol of error, evil, mystery and death, but it also suggests nobility, sophistication and elegance. In Asian countries, it is also related to darkness, mystery and night, but it additionally represents youth.

Cultural references influence and penetrate all creative work, and so in the artistic use that we make of these two values, all of these ancestral notions will be implied in one way or another.

_Yin and yang

Yin and yang are two concepts from Taoism that are used to represent the duality that this philosophy attaches to everything to do with the universe. They describe the two opposite and complementary fundamental forces that are found in all things.

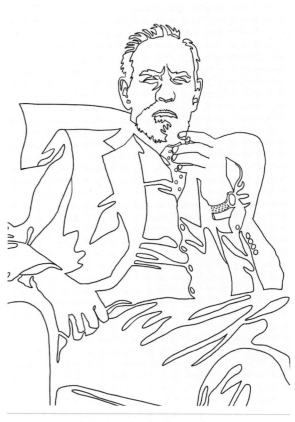

1. Portrait produced with a marker.

The different artistic techniques are related to one another, and this is why this book is interactive. Its pages contain prompts to refer to other chapters in order to get the most out of it.

The book

Technique and style change everything

In the following pages, I will explain my personal working process. As we already know, there are a thousand ways to perform any given task, and what I present to you here is simply a definition of the process that I follow when I work on a project. It's not my intention to make pronouncements or generalize.

You will also see that I have repeated a few examples to show how they appear when different techniques are used. I have emphasized this point to bring out the importance of the technique and the materials that we choose on the expression of the image that we are working on. A clear example of this is the portrait of this gentleman (◉ see page 58), which as you can see has a very different feel depending on the style applied.

A realistic approach

I have chosen to take a realistic approach when putting forward the example illustrations that I share in this book so that the technique used takes centre stage, with personal style relegated to the background. This lets us focus on what we are really looking to grasp from this book: technique.

Therefore, it is important to clarify that the examples presented are just some of the many possible outcomes of using the tools and artistic resources that are described here. You have the power to investigate and experiment with the ideas that I offer here and make them part of a constant exploration aimed at finding your own language and style.

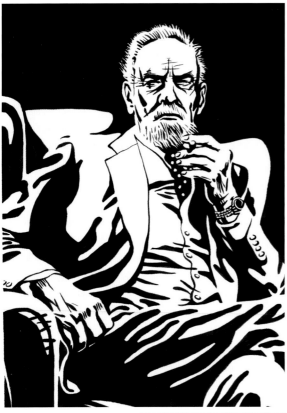

2. Portrait produced with India ink.

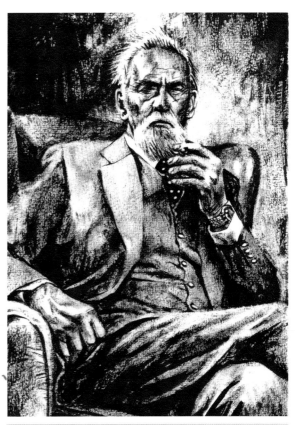

3. Portrait produced with India ink and a dry brush.

How to use this book

To complement what is described in this book, you will find different icons that are accompanied by brief advice, interesting details or clarifications related to the techniques described in each chapter.

These also make the book interactive. Its pages contain prompts to refer to other chapters in order to get the most out of it.

These **interactions** are indicated in the following manner within the text: (**See page X**)

The icons indicate the following themes:

_Artists
Information about key artists.

_Did you know...
Interesting details related to the technique described.

_QR Videos

_Also try...
Tips and exercises to help you to make progress with the technique.

_Tip
Tricks and suggestions for improving the creative process.

 QR Video
By scanning the QR codes, you can watch short videos that show the techniques being applied.

Topic 1

GRAPHITE

Gra phite

The pencil, that seemingly simple and mundane instrument, is increasingly enjoying use among contemporary artists and illustrators as an artistic technique.

A LITTLE HISTORY

The pencil, that seemingly simple and mundane instrument, is an indispensable tool in any drawing process.

Although it is most commonly deployed to sketch or set out compositions at the start of projects, its use as an artistic technique is becoming more and more widespread among contemporary artists and illustrators.

First discovery

According to historical sources, the first deposit of graphite was discovered in England in the mid-sixteenth century, and the first people to give it a practical use were the area's shepherds, who would write on their sheep to mark out their flocks. Due to the material's fragility, they wrapped it in pieces of leather so that they could make marks and write. In doing so, they

According to historical sources, the first deposit of graphite was discovered in England in the mid-sixteenth century, and the first people to give it a use were shepherds, who would write on their sheep to mark out their flocks.

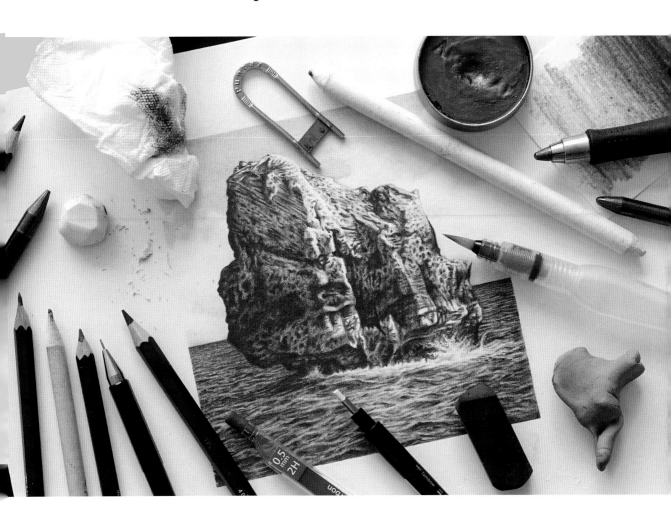

invented, albeit in somewhat rudimentary form, history's first pencils.

Sophistication and refinement

Later, more sophisticated inventors inserted the graphite into a piece of juniper wood, but soon the technique was perfected by dividing the wooden casing into two parts and placing a graphite bar directly in the centre. This version of the pencil was easier to handle.

But it was not until 1795 that *Nicolas-Jacques Conté* discovered that mixing graphite powder and clay and subjecting the mix to a firing process produced graphite bars that were much stronger and more durable.

The first pencil factory

By the nineteenth century, *John Eberhard* had perfected the invention and set up the first large-scale pencil factory in the United States.

Since then, pencil leads have been classified by the letters H, HB or B, based on the lead's hardness and according to the scale that we use and understand today. ∎

Graphite, erasers and paper

Types of graphite

Today, we can find graphite in a multitude of formats and textures for artistic use: pencils of different thicknesses and hardnesses, mechanical pencils for working with fine- or thick-point leads, graphite bars, graphite powder, water-soluble graphite and graphite paste, among others.

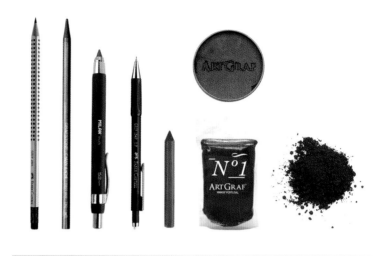

Some examples of different formats and textures of graphite.

Erasers

Another material that has evolved over the course of history alongside graphite is its inseparable companion, the eraser.

Varieties of erasers include kneadable ones, rubber ones, hard plastic ones, ink erasers, erasers in holders, eraser pencils and even electric erasers.

Kneadable erasers

These are a plastic putty whose malleability makes it possible to change their shape, stretch them or knead them. They do not tear when rubbed against the paper. They are ideal for soft graphite or charcoal. (👁 **See page 24**)

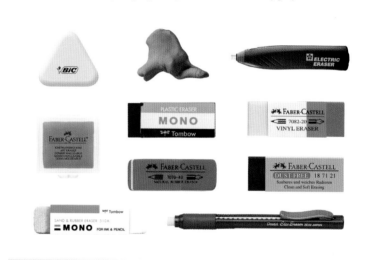

Some examples of different formats of eraser.

They can also be used to rescue and enhance whites in a drawing, as this is a tool designed to allow you to draw by erasing. It is one of the essential items for any work table.

Rubber erasers

These come in bar form and may be of different shapes and colours. They are very soft, making them ideal when working with pencil for preventing damage to the surface of the paper. The only downside to them is that, because they break down so easily, they can make a real mess on work spaces.

Hard plastic erasers

These are mostly used in technical drawing. They have a hard-wearing texture and as a result do not come apart as much as rubber erasers do. However, because they are harder, they can damage the paper.

Paper

Another very important element that we must choose with care when working with a given technique is the type of paper that we use. Paper can come in glossy, textured, handmade, machine-made, cold-pressed and hot-pressed forms, among others. Choosing the right support medium will allow the applied technique to be more effective.

_Breadcrumbs

Before the eraser was invented, people used wet breadcrumbs to remove graphite. If one day you happen to not have an eraser with you, this is a good trick to get by, though the crumbs have to be from fresh bread, otherwise it does not work.

The sketch, as a departure point

The best approach

A sketch is an outline or guide that seeks to capture basic ideas that will become the structural foundations on which an artistic work will be developed. It is produced by hand on any type of support (for example, paper or canvas) and does not require any auxiliary drawing instruments.

It is, of course, possible to illustrate or paint directly, without the need to make sketches, as artistic creation should not be held back, and nor can it be. In my own case, sketching has always been a very important part of my creative process, as sketches are where I develop the plastic and conceptual aspects of the final illustration. Sketches give me the chance to move things around and scrutinize them as well as test out and ultimately choose the best approach. (👁 See pages 72 and 74)

Always having a small drawing kit to hand is a good habit that lets us practise techniques and explore new compositions and graphical approaches.

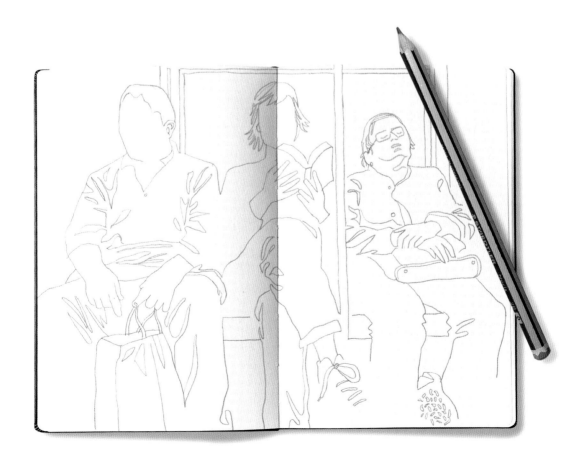

1.1
Pencil

A rock in the Caribbean

To focus on this technique, I have chosen an image of an unusual rock located in the waters of the Caribbean, near Bermuda.

In this composition, we have three of the essential elements that define a landscape: sky, land and water. In nature, the three elements coexist in harmony, but artistically speaking, they have temperaments and characteristics that are so individually peculiar and different from one another that sometimes it is difficult to master them and graphically render each one of them the appropriately.

Graphite pencil

The pencil, at first glance one of the simplest drawing instruments, is actually very versatile and offers a fascinating level of variety, and we shouldn't underestimate its artistic potential, since it may become our closest ally.

Classification and gradient

As I mentioned earlier, pencils are classified and graded using a system comprising the letters **H** and **B. The letter H**, refers to hardness and **the letter B** to blackness.

As we can see in the following table, the classification system for pencil leads goes from hardest (9H), which draws a fine and light line, to softest (9B), which traces a soft and very dark line. HB is the midpoint.

Different lead hardnesses

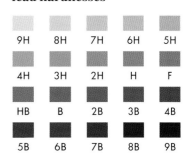

We will begin to work on the sky by applying just a little pressure with the pencil, and we will make use of blending to shade and soften the sky and produce a homogeneous grey tone with subtle gradations.

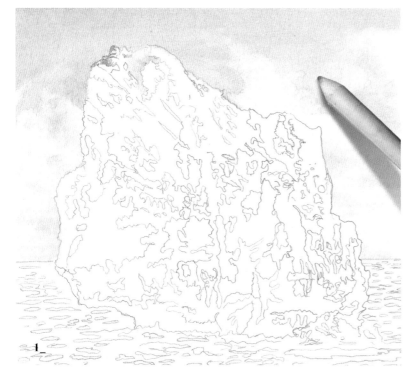

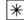

✳

_Blending tools

These are indispensable for working with graphite or charcoal. They help us to blend lines, smooth contours and produce midtones. We choose the right size and thickness based on the type of drawing that we are producing. In this case, I used a medium-size one.
(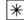 **See page 22**).

However, if one day you don't have one to hand, you can make your own blending tool with kitchen paper, or even more simply, you can use your own fingers to blend.

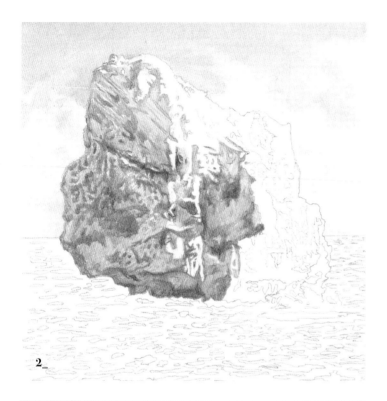

2_

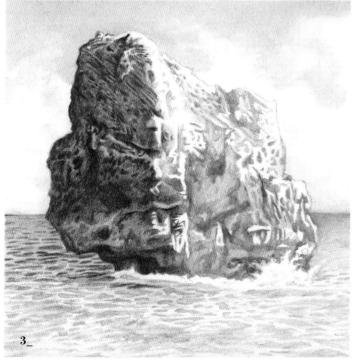

3_

Method

1_ First, we draw the image of the rock in the sea by marking out its lights and shadows. We will trace the drawing onto a piece of smooth 250 g paper with a 2H pencil, redrawing the profile and all areas of lights and shadows with a closed contour, as is shown in Picture 1. This will give us a guide and make it easier to place light and shadow when we focus on that aspect later.

1+2_ We will render the sky with a 2B pencil, applying just a little pressure and producing our lines very gently. Our blending tool (👁 see page 22) will help us to shade and soften, producing a practically homogeneous light grey.

2+3_ Aided by the tracing's guide for the contours of the lights and shadows, we will begin to "paint" the rock with H, HB, B, 2B and 3B pencils, applying them in that order (which goes from hard to soft).

_Martí Cormand
Part of this Brooklyn-based Catalan artist's work involves pencil versions of legendary works by conceptual artists from the sixties and seventies, which he produces in a technically flawless hyperrealist style.
www.marticormand.com

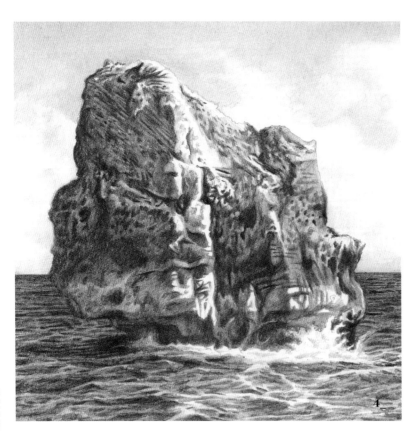

Method

3+4_ Once we reach the sea area, we will work with the same pencils, applying them in the same sequence as we did when we were working on the rock (that is, from hard to soft).

4_ With a 5B pencil, we continue increasing the intensity of the whole illustration, enhancing and highlighting the shadows to give the different elements depth and volume. With an 8B pencil, finish off the more intense shadows.

Last step_ To finish the drawing, we will bring together the details, and with a kneadable eraser we will rescue the whites and the brightest points of light from the rock, the foam and, above all, the waves of the sea.

To protect the drawing and prevent the graphite from smearing, we will set the pencil with a special fixative spray for graphite.

The three elements

_Sky
To achieve the sky's softness and midtones, we have used a soft pencil and a blending tool.

_Land
To define the rock's creases and hardness, we have combined soft and hard pencils.

_Water
To enhance the glare from the waves of the sea, we have used the kneadable eraser as a drawing tool to achieve the final result.

_Drawing by erasing
Draw by erasing is an alternative way of drawing. In the example, I have rescued the lights of the sea using a kneadable eraser, but you can actually create very powerful illustrations by applying an eraser to a graphite background. Give it a try; you'll be surprised by the results. (👁 **See page 12**)

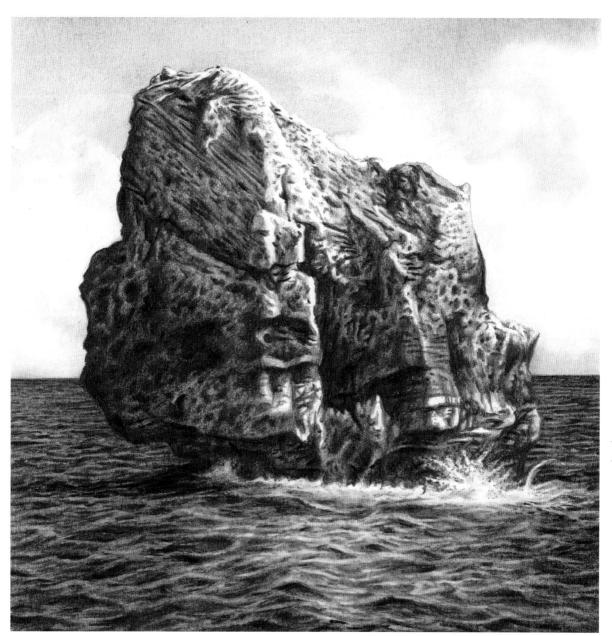

To protect the drawing by preventing the graphite from smearing, we will set the pencil with a special fixative spray for graphite.

_Masking tape
If you protect the margins of the drawing with masking tape before you begin to trace (see page 22), the rectangle that frames your drawing will be delimited and completely clean.

1_

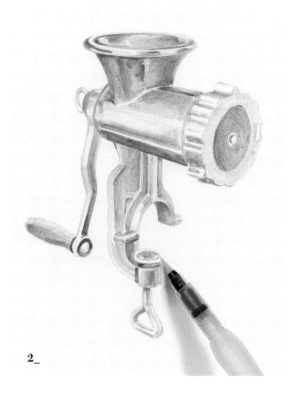

2_

1.2 Water-soluble graphite

In this instance, we will work with water-soluble graphite paste, which you can find in specialist stores.

Metal

To depict this manual meat grinder, I used a tin of water-soluble graphite paste (◉ **see page 13**). I have chosen this item because of the wide range of gradations and shapes that we can see in its metal body. These make it an ideal model for working with this material.

A wide range

There are countless types of water-soluble graphite on the market these days. Among others, there are:

Water-soluble graphite pencil

Like other watercolour pencils, this can be used in dry form, with water applied afterwards with a brush.

Graphite paste in a tin.

Water-soluble graphite bar

Graphite bars can be used in a similar manner to pastels, with water subsequently applied to the strokes using a brush.

Water-soluble graphite putty or paste

These are ideal for use in a mixing palette; small portions can be placed in each hole and different grey tones can then be obtained.

Method

1_ With the help of photographs or a real version of the object, we will draw a meat grinder, subsequently tracing it onto a fine-grain 200 g watercolour paper.

2_ Gradually, going from light to dark and using a synthetic brush with a water reservoir, we will apply the graphite in layers. We will slowly increase the intensity, leaving the darker shadows to the end.

Last step_ Use a water-soluble graphite pencil to profile the last details and finish off the illustration.

QR video
Scan the code to see a small sample
of how you can apply water-soluble graphite.

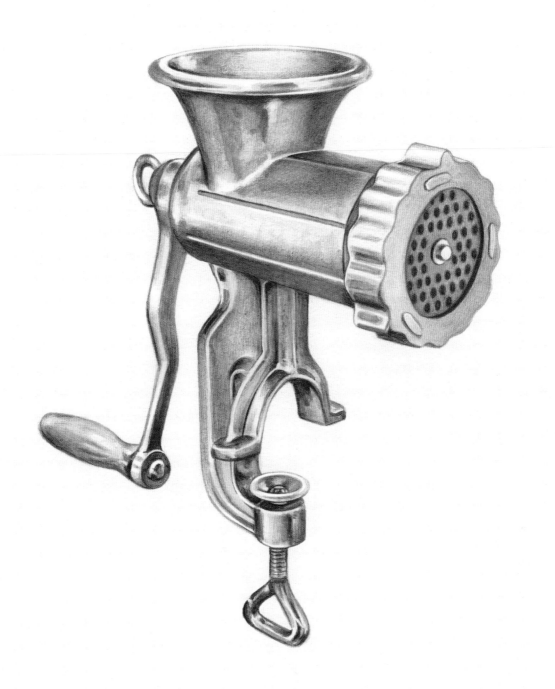

Charcoal and chalk

One of charcoal's main qualities is its great expressiveness, especially when it is used in compositions involving light.

A LITTLE HISTORY

Since prehistoric times, human beings have expressed their experiences and desires through drawing, and we can see their first strokes in the hunting scenes that our ancestors depicted on cave walls. To make these pictures, they used four main colours, all of which they extracted from natural elements.

Red and brown were extracted from iron oxide, while yellow was obtained from pollen. Black, which was used to depict human figures, came from charcoal.

A prehistoric material

It could be said that charcoal is probably the first material that human beings used to draw and depict hunting scenes in their caves, and we have continued using it to this today.

Charcoal is the first material that human beings used to draw on cave walls, and it continues to be one of the most commonly used drawing instruments for artists and illustrators.

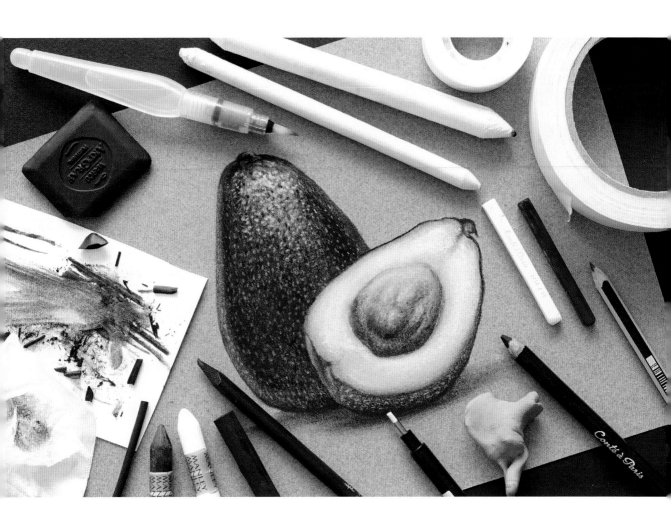

What is it?
Charcoal is made from smooth and knot-free grapevine, willow, evergreen oak, birch or heath branches, which are burned until they become a smooth and soft charcoal. The product is then sold in various thicknesses.

Charcoal has probably been the most widely used material over the course of art history by artists, who have applied it in producing drawings, paintings and sculptures. Sometimes they have simply used it for sketching, and many other times as the material applied in their final work.

Among the different types and formats of charcoal are the following:

Pressed charcoal
Pressed charcoal mixed with a binder or clay is available in bar form. Its stroke is dark and dense, but it is also difficult to erase or blend. It is sold in three levels of hardness.

Conté or charcoal pencils
These are made from charcoal mixed with a binding substance that gives them their consistency. They have a wood casing and therefore can be sharpened just as pencils can. They let us make fine and accurate lines. They are manufactured in six levels of hardness. ∎

Blending tools

As I described earlier, these are cylinders of rolled paper whose ends finish in a tip. They are used to blend strokes, smooth contours and achieve midtones. They are sold in different thicknesses and hardnesses, and there are also mini and pocket versions, which are easy to carry around when doing in situ drawing.

It is important to prepare blending tools before you use them for the first time by beating and sanding them a little, and the best way to keep them clean is to use a fine sandpaper.

When you are working, it is advisable to keep one tip reserved for dark tones and another for light ones in order not to mix or contaminate values when applying the blending tool.

Charcoal paper

We have to be wary of very smooth or glossy papers, as charcoal won't adhere to them. The ideal paper for this material is **laid paper**, or any other type of paper with some degree of porosity and texture. (👁 **See Figure**)

Fixative

It is very important to set the coal once you have finished your piece using a fixative spray. You can also use hairspray, though over time it can yellow the paper.

Masking tape

Masking tape is an adhesive paper tape that is easy to remove. Its main function is to protect areas that should not be painted.

Masking tape, double-sided sticky tape and blending tools are some of the materials that we will use.

When you use blending tools, it is advisable to keep one tip for dark tones and one for light ones. This will stop us from mixing or contaminating our values.

2.1
Charcoal

The avocado

Avocados have a dark, rough, organic skin that is full of exquisite shades, and this is what attracted me to them as an opportunity for exploring the charcoal technique.

Charcoal bars

As I mentioned above, these are fine branches that have been burned to turn them into charcoal. Their softness means that charcoal will come off the bar when it brushes against paper, and they are strong enough to stand up to being handled when they are being used for drawing.

Blending

Blending is the act of smoothing, softening or blurring different areas of an illustration. Items that can be used to perform this action include blending tools, cloths and cotton swabs. But we must also remember that the most effective tool for blending is often our own fingers.

_Sealing the masking card

We will stick down our masking card with masking tape and re-movable double-sided sticky tape, seeking to ensure that the area that we want to keep clean is fully sealed off. This will stop charcoal dust entering the protected areas. (👁 **See Figure 3**)

_Protective masking

Before starting to paint, we will use a fairly thin piece of card to make two pieces of protective masking: one for the background and another to protect the fruit.

Figure A
The negative silhouette will help us to protect the background.

Figure B
The positive silhouette will help us to protect the fruit.

2_

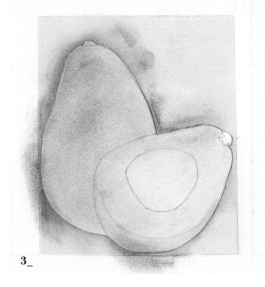

3_

Method

Based on photographs or the fruit itself, we will draw our avocado. Once the drawing is ready, we will trace it on special 250 g paper designed for charcoal.

A+B_ We will prepare some pieces of cardboard masking to protect the areas that we do not want to get dirty when we begin working with our charcoal.

2+3_ Once the masking card is affixed over the drawing, we will begin to give volume to the avocado using charcoal bars.

4_ We blend the charcoal with our finger or blending tool, making the patches of it uniform.

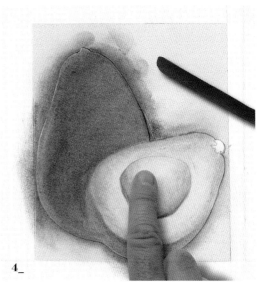

4_

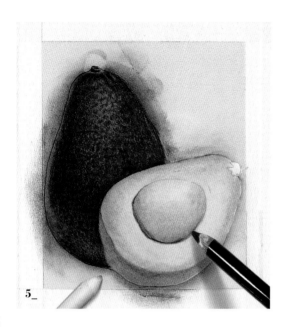

When it's time to remove the protective masking that we have been using, we should check that our drawing has perfect definition, with no trace of charcoal in protected areas.

_Cotton cloths
To clean dirty areas or dust stains, the best thing to do is to use a cotton cloth.

5_

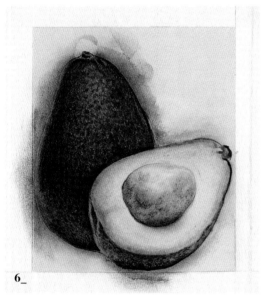

6_

7_

Method

5_ Using a sharp charcoal pencil, we will alternately profile areas and blend strokes. With a blending tool, which is a more precise instrument than our fingers, we will also shade some areas.

6_ With a kneadable eraser (👁 see page. 12), we will render the details that we want to highlight in the brightest areas, such as light reflected from the avocado's skin.

7_ We remove the masking for the background, making sure that our drawing has perfect definition and that there are no traces of charcoal in the protected areas, and then we carefully put in place the positive version of the masking, which will protect the drawing itself so that we can work on the shadow with greater peace of mind.

Last step_ Remove the masking from the fruit, profile the last details and finish off the drawing.

To protect the drawing and stop the charcoal from getting smudged, we will set it with a fixative spray.

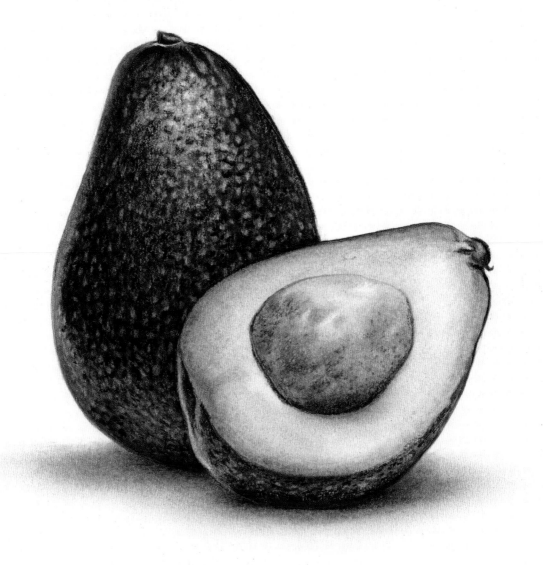

_William Kentridge (Johannesburg, 1955)
This multifaceted South African artist, painter, engraver, collagist, sculptor and photographer has also produced legendary animation. His films are unmistakable owing both to their mostly black and white aesthetic and to his technique, which consists in drawing and erasing charcoal in succession.

The result of the animation process is a semierased image that slowly metamorphoses, adding mystery and drama to the piece.

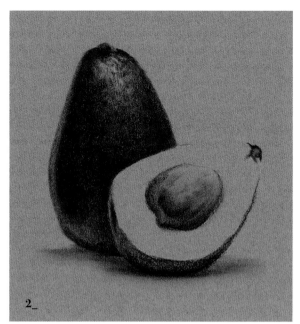

Black and white chalk bars.

2.2
White chalk, black chalk

Chalk is rich in shades, because it offers us the possibility of creating dense and opaque surfaces or light and transparent ones.

A resourceful material
Chalk is a material that offers great possibilities, whether we apply it in layers or in strokes, and it offers us the possibility of creating dense and opaque surfaces or light and transparent ones.

Changing support medium
We will continue with the image of the avocado because it is interesting to see how a given element changes depending on the colour of the support medium. In this case, we will work on a **grey 160 g Canson® paper**. This grey tone will be our base and give us the midtone that will unify the illustration.

Method

1_ We will transfer the drawing of the avocado that we made earlier for the example from the previous section to the grey support medium, doing so with the help of white tracing paper.

2_ We will begin to give form to the avocado (including shadow) with a bar of black chalk, using our fingers or a blending tool to blend and create tones.

In the same way, we will mark out the light parts and reflections off the skin with a bar of white chalk.

Last step_ We refine the details with chalk pencils and unify tones and shades, finishing off the drawing.

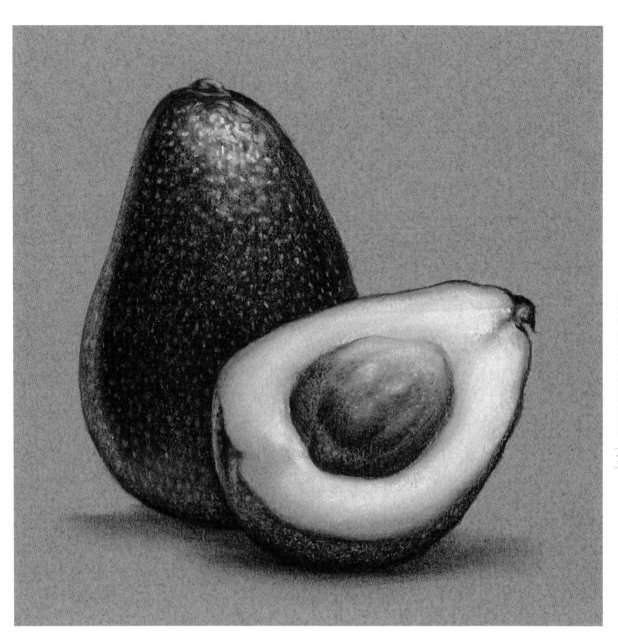

Working on a grey support medium will always lend a unique character to our illustrations. The emphasized lights will provide a special softness and elegance to the scene.

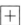

_Recycled grey cardboard
When it comes to choosing a grey-coloured support medium, we can go beyond the classical drawing papers and find more rustic materials such as **solid recycled grey cardboard**, which is usually used as a rigid base for mountings, bindings and so on. Cardboard of this type will lend quality, texture and personality to our work.

Topic 3
THE MARKER PEN

The mar ker

There is a wide range of professional markers, many of which stand the test of time and can be applied to almost all types of support media.

A LITTLE HISTORY
The origin of the marker goes back to antiquity; the first ones, made of felt-tipped bamboo, originated in Japan.

A Japanese invention from the sixties
However, the modern marker with a felt or nylon tip as we know it today was invented in 1962 by Japan's *Yukio Horie*.

A medium of great expressiveness
Marker pens are ideal for quickly producing ideas, but they also amount to a method for obtaining spectacular results if we use them for a final artwork. This medium offers great expressiveness and character, and we can apply it using different techniques, such as hatching, scribbling, pointillism

In addition to being fast and comfortable, markers also allow us to obtain spectacular results if we use them as a technique for our final finishes.

and erasing. And we can use markers for line drawings, applying them to produce lines in one stroke, or we can combine strokes of different thicknesses.

Between scribbling and painting technique

In addition, if we choose to use water- or alcohol- soluble markers, we can adopt an approach that comes closer to painting, obtaining results similar to watercolour and being able to produce gradation and fading effects that are more artistic.

For all tastes

Nowadays there is a wide range of high-quality professional markers, many of which stand the test of time, are light resistant and can be applied to almost all types of support media imaginable, such as plastic, metal, wood or glass, among others. ∎

The harder the tip, the better defined the lines and details will be; the softer it is, the easier it will be to apply ink over large areas.

Some examples of different marker strokes and hatching.

Some examples of different types of marker tip.

Marker strokes

Tip hardness
As I mentioned earlier, marker tips are usually made from felt (which is softer) or synthetic fibres or nylon (which are harder).

The harder the tip, the better defined the lines and details will be; the softer it is, the easier it will be to apply ink over large areas. In addition, soft tips also allow us to produce more subtle fading and gradation.

Types of tips
In addition to tip hardness, we can choose between different types and shapes of marker tips. These are some of the commonest types:

◆ Chisel tip
The great virtue of this tip is its versatility, as it allows us to draw two or three different types of lines within the same stroke. These lines will be wider or thinner depending on how we angle the tip against the paper.

◆ Bullet tip
These tips do not allow us to create such a variety of strokes, but they are more suitable for detailed and thorough work.

◆ Fine tip
Fine tips are ideal for working on details, making final touches and hatching. (👁 See page 42)

◆ Brush tip
This tip is very suited to more artistic projects, gestural drawings or water-based illustrations.
(👁 See page 44)

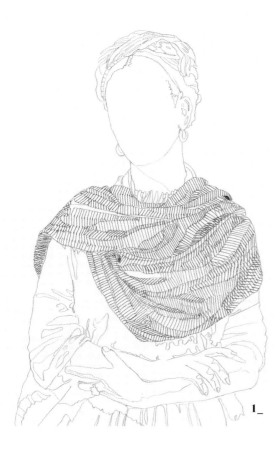

Method

1_ First of all, inspired by *Muray's* photograph, we will draw *Frida*. We will trace the drawing onto a 250 g glossy paper with an H pencil, redrawing both the profile and lights and shadows of the image with closed-contour areas.

1_

Hatching is any kind of combination of points, lines or strokes that constitutes a graphical sequence.

3.1
Hatching

Frida's shawl
To explore the world of hatching, I was inspired by a photographic portrait of *Frida Kahlo* that was produced in the thirties by the Hungarian photographer *Nickolas Muray*, who had a ten-year romance with the artist.

In this case, what makes this image suitable for the hatching technique is *Frida's* shawl, its volumes and its folds—those soft dunes full of shades.

What's hatching?
Hatching is any kind of combination of points, lines or strokes that constitutes a graphical sequence. Hatching in drawing involves producing intersecting lines in different directions to depict the volume of the surface drawn.

This technique is characterized by the possibility of creating grey tones based on the distance and the overlapping of interrelated strokes.

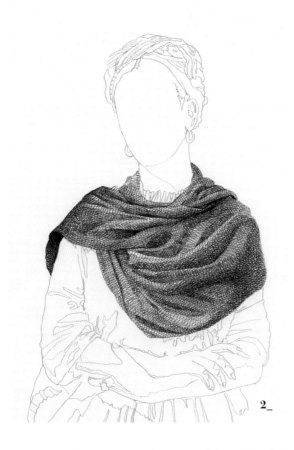

Method

1+2_ Once the drawing has been traced, we will begin to work on the hatching using a marker with a thickness of **0.1**. We will first draw parallel lines that are slightly apart and follow the same direction, creating a uniform grey base on which we will establish the later layers of strokes that will proliferate over it.

3+4_ To be able to correctly interpret the lights and shadows, it is important to change the direction of the hatching, in order to adapt the strokes to the different volumes of the shawl.

4_ Being aware at all times of each line, we will add overlapping layers, configuring an intersecting and increasingly dense hatching. If the lines are closer together and the hatching is thicker, we will create dark areas. If, by contrast, the strokes are further apart and the hatching is less dense, we will obtain brighter areas.

2_

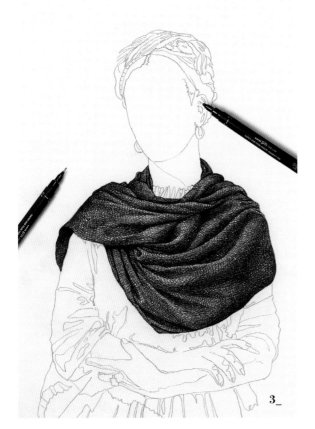

3_

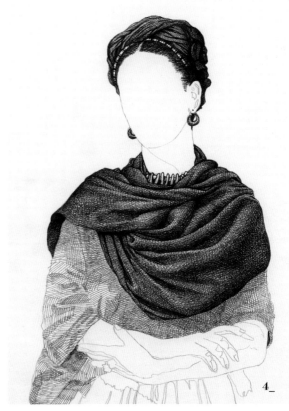

4_

QR Video
Scan the code to see a small sample of how you can produce hatching with a marker.

_Olivia Kemp

This British artist, a virtuoso with a fine-tip marker, produces large-size, mysterious megalandscapes, strictly in black and white.

She creates her worlds out of a mixture of cities, plants and animals from different places, and she achieves harmonic and very detail-rich compositions that invite the viewer to delve into them in search of more. In fact, she "hides" some figures in her compositions, waiting for attentive viewers to discover them.

Another interesting detail is that this artist works "from memory" —that is, she does not make any preparatory drawings and instead draws directly on the paper, improvising the strokes as she goes.
www.oliviakemp.co.uk

To be able to correctly interpret the lights and shadows, it is important to change the direction of the hatching to adapt the strokes to the different volumes.

Types of hatching

Although hatching can be done in a completely free and personalized way, with there being no rules to follow in the creation of the hatching's architecture, some of most commonly used types of hatching include cross, honeycomb, dotted or pointillism, multidirectional (very appropriate for backgrounds), smudged, erased, and parallel hatching.
(◉ **See pages 42 and 68**)

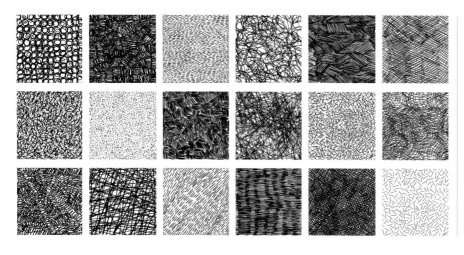

Each type of hatching provides different connotations: balance, movement, calm, strength and so on.
The possibilities for creating different types of hatching are unlimited and depend on our own experimentation.

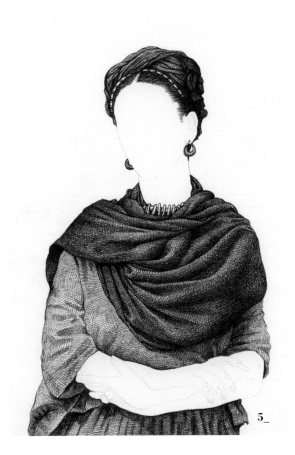

Method

5_ From this point on, we will continue to apply more strokes to the darker areas, always emphasizing the pattern of intersecting strokes.

Using a marker with an extra-fine tip and a 0.4 thickness, we will apply a final hatching layer to the darkest areas to give the illustration the required depth and contrast.

Last step_ To bring light to the image and balance it relative to the density of strokes that make up the clothing, we will give the face, arms and hands a more minimalist and cleaner finish.

We will analyse the composition as a whole, retouching and bringing together details, and the illustration will then be finished.

To produce this drawing, I used only three markers with extra-fine tips (0.1, 0.3 and 0.4).

_Other hatching types
In this section, I have talked about hatching made with a marker, but it is of course possible to create hatching with the other tools described in this book, such as ballpoint pens, pencils, bamboo, nib pens or brushes.
(◉ **See pages 14 and 68**)

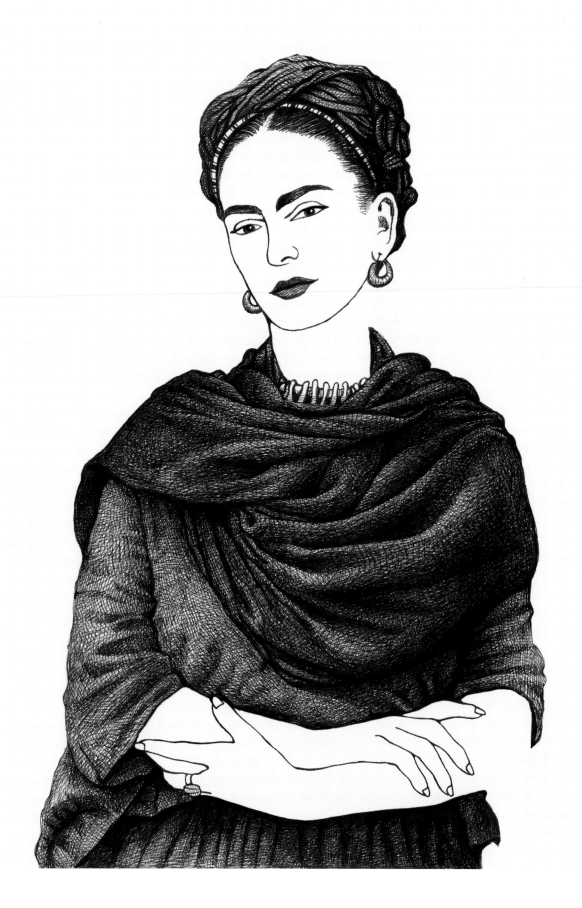

1_

3.2
Uniform stroke

The black thread

In this section, we will work on a picture of three people gathered around a table in a bar. Their poses, clothing and hair and the profile of the objects that are distributed on the table make the picture seem ideal for working with a single marker with a uniform stroke.

To the untrained eye, this approach may seem bland, but believe me, nothing could be further from the truth. Using whites as a key element in the composition and in addition to our stroke is exciting. In this case, my intention is to create an ethereal and subtle illustration in which the line will slide over the surface like a single black thread.

Drawing the absence of elements and analysing the whites as essential segments of the illustration will enrich our composition.

Method

1_ We will begin our drawing with an HB pencil with a **0.5 lead**. We will pay great attention to the outlines of the elements that we will go over again later on.

Last step_ We redraw the sketch using a marker with an extra-fine **0.4 tip**, applying it perpendicular to the paper to ensure that the line is uniform, and we will not redraw certain parts to achieve the ethereal feeling that we're looking for. To finish things off, we will erase the residual pencil lines.

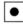

_William Anastasi
This American conceptual artist is famous for his *subway drawings*, which he produces while he is travelling around. While sat down, he places a notebook over his legs and lets the movement of the subway train move his pencil freely.

He is also known for his *drawing pockets* or *walking drawings*, which he creates by putting his notebook and pen in his pocket and letting his walking movements determine the drawings.

Drawing with a single stroke

One of the most interesting and fun exercises that can be done with a marker (and also with other implements) is to make drawings with a single stroke—that is, drawing a scene without lifting the marker from the paper at any point.

Drawing with our eyes closed

Another exciting exercise that I propose is to closely observe an object, keep it in your memory and then close your eyes and draw it blindly, trying to transfer the image in your mind to paper as faithfully as possible. (👁 **See page 127**)

A

Figure A
Example of a still life produced in situ with one stroke.

Figure B
Example of a still life produced in situ with closed eyes.

B

In addition to being fun, both of these techniques activate your ability to synchronize and encourage your control over the space, surface and proportions, providing you with mental agility and therefore greater compositional skill.

3.3
Uneven Stroke

A surprising instrument

The saxophone has always seemed like a musical instrument from science fiction to me: the composition and overlapping of its unique elements remind me of the futurist structures that fill **Moebius** comics. Because of those peculiar multiform mechanisms, I consider it very suitable for drawing. In this case, I'll do so using markers of various thicknesses.

It is important to clarify once again that, as with all the examples in this book, the sample presented here is just one example of the endless illustrative possibilities that this artistic resource has to offer. Investigating, testing and exploring are indispensable tasks that will help you to transform the ideas suggested here into new and personal artistic creations. (👁 **See page 122**)

MARKERS

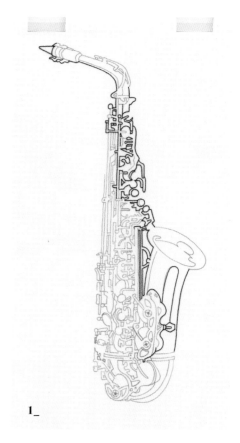

1_

Working with a fine-tip marker will make things easier for you, since during the second stage you will be able to cover lines and correct imperfections that would otherwise be impossible to retouch.

Method

1_ Working from real life or a photograph, we will draw our saxophone in pencil on a piece of paper. Once finished, we will directly trace it using a marker with a fibre, extra-fine **0.4** tip on tracing paper affixed to the sheet with removable adhesive tape.

2_ For the second step, this time using a marker with a **1.2**, size felt tip, we will trace areas of the saxophone that we've decided to produce with a thicker stroke to create contrasts.

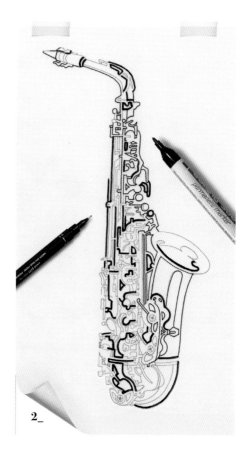

2_

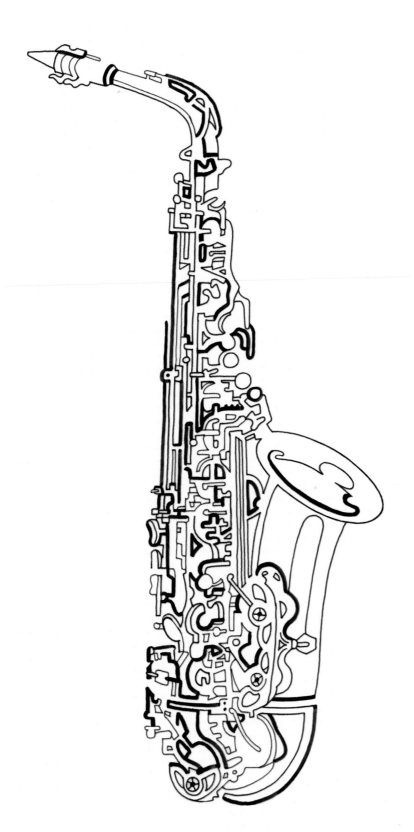

Last step_ When we have achieved the levels of contrasts between lines that we were looking for, we will call the illustration finished and, if we wish, we can scan it to get a compacted drawing with a white background.

To achieve greater control over the two types of stroke, you could work by using a sheet of tracing paper for each line thickness and then scan everything and bring it all together.

_Pep Carrió
Al otro lado de línea is a unique volume by this magnificent Mallorcan artist. It brings together a selection of automatic drawings made by the author during telephone conversations from between 2010 and 2012.

This artist's book is full of illustrations made from lines that seem to have no beginning and no end and whose only plot is an unconscious narrative with a strong, dreamlike component.
www.pepcarrio.com

3.4
White marker

A little more saxophone

I thought it would be interesting (as I did in other cases that we have already seen in this book) to repeat the sample image in another example—in this case, white marker on a black background. If we compare this with the previous example, we will be able to appreciate the differences that appear when we change an image from positive to negative. We are talking about the same object, and practically the same stroke. But, suddenly, everything changes.

Jazz and night time

The saxophone was invented by *Adolphe Sax* (hence its name) in around 1840, and it is associated with popular, big band and jazz music. Jazz, in turn, is associated with the night time, and this is why in the illustration the white profile works so well on a black background. A mechanical skeleton stretches out over a labyrinthine mesh of white strokes to produce an iconic musical silhouette.
(👁 **See pages 97 and 122**)

We will begin by drawing the details of the saxophone with a white gel-ink marker with a 0.5 thickness. It is important to not be in a hurry and to render the lines meticulously, because this ink cannot be erased.

We can also use white markers of different thicknesses.

1_

Method

1_We will draw our saxophone in pencil on a piece of paper, defining all the details that we want to illustrate. Once the drawing is finished, we trace only the profile of the saxophone onto black card, with the help of white tracing paper.

After transferring the instrument's profile to the black card, we will begin to draw all the details of the saxophone with a white gel-ink marker with a **0.5.** thickness. It is important to not be in a hurry, because this ink cannot be erased.

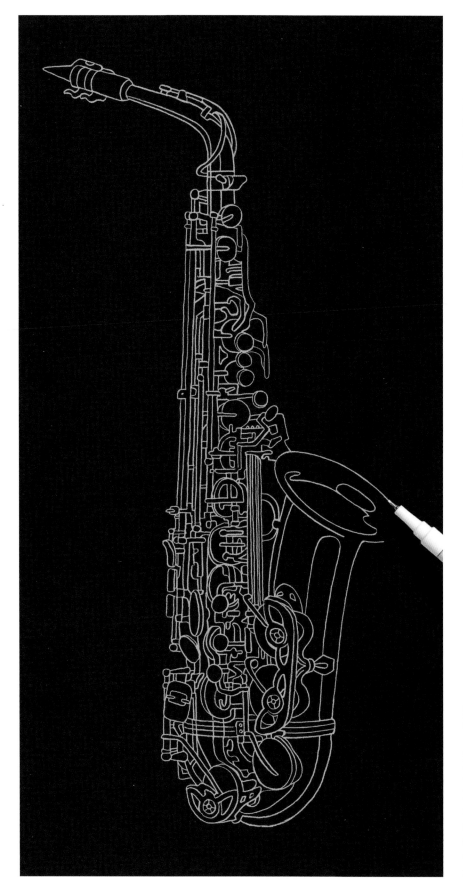

Last step_ We will carefully erase all remnants of the tracing on the surface of the card with a soft eraser and working very gently, so as not to smudge the white ink.

✳

_Negative
If the illustration that you are going to produce is not linear, make sure it is an image with a lot of contrast, since when working in negative we do not have a range of greys. (◉ **See pages 59, 101, 104 and 110**)

QR Video
Scan the code to see a small sample
of how you can apply pointillism.

3.5
Pointillism

Artistic movement

Pointillism is a painting technique that consists of creating an illustration or painting through the application of small points that, when viewed from a distance, comprise a well-defined image. The method is more than a drawing technique, as pointillism was in itself an artistic movement in the nineteenth century. In this section, we will work with pointillism as a form of hatching that uses points. And, like all hatching, it works through distance and density. If we fill an area with just a few points that are far from each other, we will draw a light grey. If to that same area we add more points and ones that are closer together, we get a dark grey. The head of a rooster, with its varied volumes and organic textures, will offer us the whole achromatic spectrum that we need to develop this work-intensive technique. (👁 **See pages 31 and 33**)

_Solveig Gaida
This German artist creates drawings with a high level of realism, based on executing the pointillism technique with a marker.

She uses this technique because she is fascinated by the way in which the final outcome is greater than the sum of its parts. The interaction of black and white creates a unified whole but, if we look closely, the composition disintegrates into tiny points.
www.solveiggaida.com

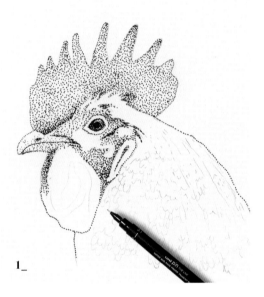

1_

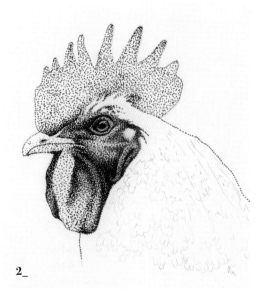

2_

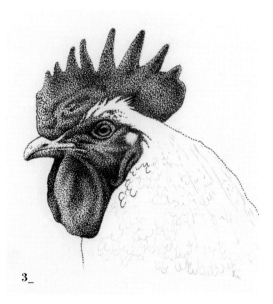

3_

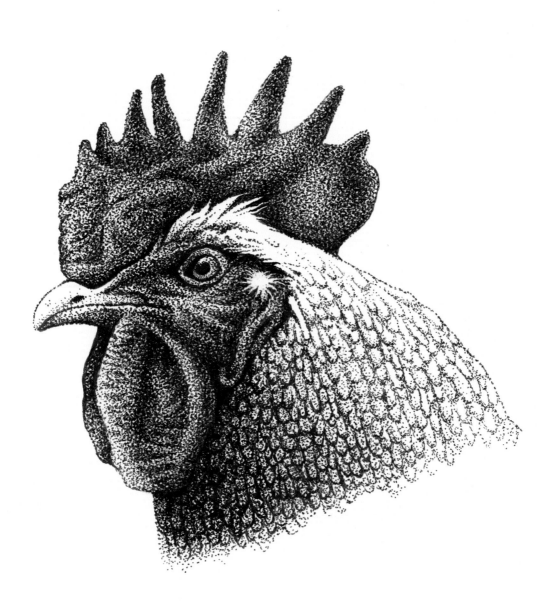

Method

1_We will begin by drawing the head of the rooster and marking out the lights and shadows with closed-contour areas.

1+2_We will begin creating points with an extra-fine fibre-tip marker with a **0.1** thickness, working first on the light parts with small and separated dots, and progressing from less to more intensity.

3_ Little by little, we will reduce the distance between points and increase their density to profile the shape of the animal's volumes.

Last step_ Finally, using a marker of the same type and with an extra-fine **0.3** tip, we will add layers of points to darken the shadows and create the gradations needed to shape the image's complex corporeality.

_Marker position
It is important to work with the pen completely perpendicular to the paper to obtain harmonic, uniform and accurate points.

3.6
Water-soluble marker

Monet's water lilies

I've always liked *Monet's* water lilies. I saw them for the first time in the *Musée de l'Orangerie* in Paris a few years ago. When I had the idea for a book on black and white techniques, in a sudden flash, a sharp image of *Monet's* water lilies came to me, and I asked myself: What would they be like in black and white? That idea inspired me, since several elements that might help me to explain this technique coexist in those water lilies—for example, the leaves, water, transparency and, above all, the broad spectrum of grey tones that surrounds their ecosystem.

What is a water-soluble marker?

We can find many types of water-soluble markers on the market. They come in different brands, thicknesses and types of tips, but the characteristic all of them share is that their ink becomes diluted when it comes into contact with water, which creates mixes and gradations that are very are similar to those we can produce with watercolours.

Water lilies in black and white

In this case, we will create the picture of water lilies with a single black water-soluble double-tip marker. One tip is the shape of a brush, is flexible and sensitive to pressure, and produces various thicknesses for expressive strokes, and the other is a fine tip that is for greater precision in details.

Grey-tone markers

The grey scale is a continuous modulation from white to black, and it is used to establish lightness and darkness, as well as all of the tones in between.

Although in the sample drawing I used a single, purely black water-soluble marker to show the wide range of possibilities that we can achieve with a single instrument, having a good set of **grey markers** can be very useful for creating bases, painting middle shades, adding intensities and producing other shades that will make our tonal range more extensive.

Having a good set of grey markers can be very useful for creating bases, painting middle shades, adding intensities and producing other shades that will make the tonal range more extensive.

_Joe Munro
This English artist who draws live and in situ is a kind of graphical reporter who captures moments of great intensity in his illustrations—for example, the hectic atmosphere of a restaurant kitchen operating at full pace, the expressions of a pianist playing live or Cuban streets crowded with people.

He uses both ink and brush markers for his creations, since these help him to work based on instinct.
www.joemunro.com

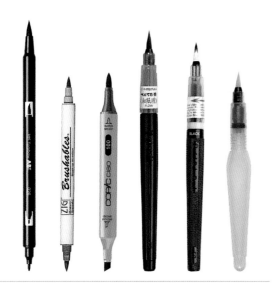

We can use markers with different types of brush tips.

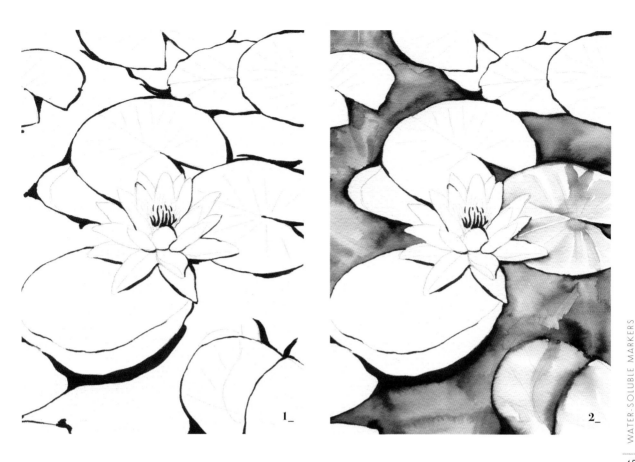

1_ 2_

The depth of the pond

The depth of the pond helps us to understand the light and shade. Everything depends on objects' distance from the surface. The submerged elements that are closest to the surface will be lighter because they will receive more sunlight, while submerged elements that are further away from the surface will be darker in line with the progressive lack of light on them.

Brush-tip markers are also intended for use in dry techniques, and the tip of your brush will allow you to create different thicknesses and strokes depending on the pressure you apply.

QR Video
Scan the code to see a small sample of using water-soluble markers.

Method

First, we will draw the water lilies with pencil, either from real life or using photos. We will then trace the drawing onto 250 g fine-grain water-colour paper with a softer B pencil.

1_ With the brush tip of the marker, we will profile all elements that are in the water (almost 90 per cent of the surface of the image). In the case of the white flower of the water lily, we will only profile areas that have contact with the water, leaving the rest untouched.

Method

2+3_With a no. 4 sable-hair brush, we will begin to moisten with water all strokes that affect the submerged areas of the plant, mixing tones and continuing with the marker on the wet areas and seeking, through the range of greys, to convey the depth of the pond. We repeat this process until we achieve the desired result.

4_With another glass of water and bleach (half and half) and a simple no. 2 synthetic-hair brush, we will subtly draw some of the veins that we want to highlight in the leaves of the lilies, to detail them and give them more volume. The bleach discolours the ink from the water-soluble marker, and as a result we can

obtain lightness based on a set of darker tones. (👁 See page 84)

Last step_We finish the unprofiled flower with the marker, thus maintaining its subtlety. We will only apply soft grey tones that we will take from a dark area of the illustration, gently

massaging the brush dampened with water and then applying it to the leaves of the flower to achieve the required volume.

To finish, we can use a white marker to enhance some points of light. (👁 See page 40)

The challenge with this image is to achieve the transparent effect of the pond water using a single black water-soluble marker as our tool.

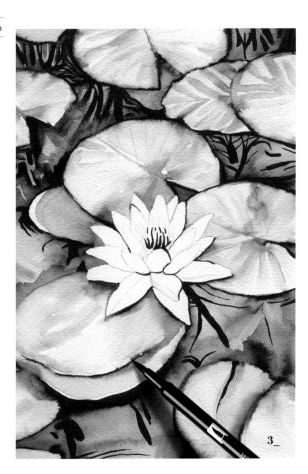

3_

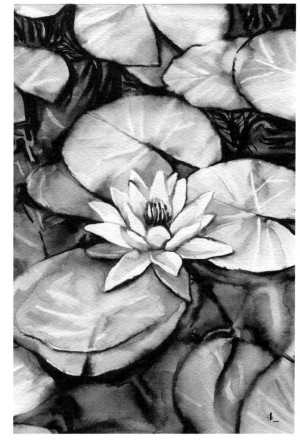

4_

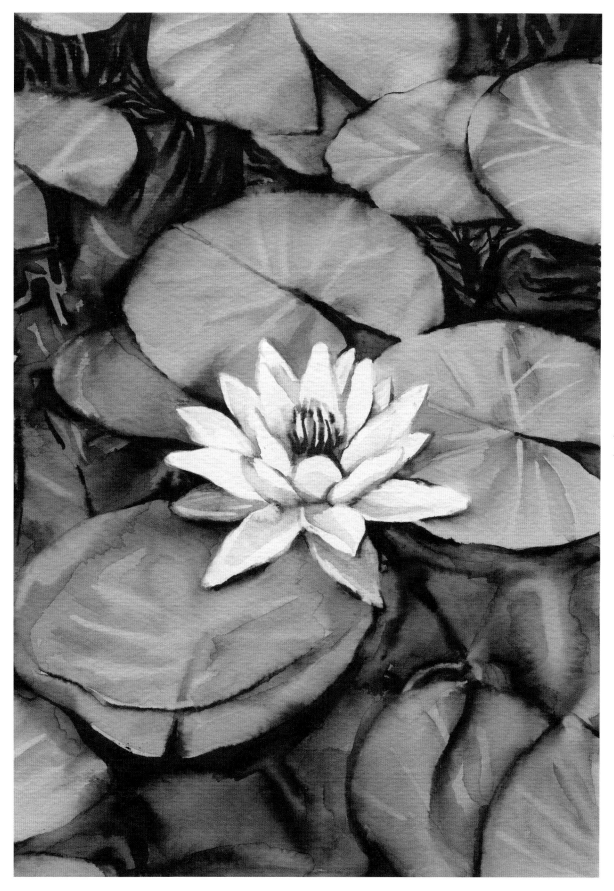

The ballpoint pen

Beyond its use for writing, which was the reason for its creation, the ballpoint pen is used nowadays both to illustrate and to create artworks.

A LITTLE HISTORY

It is said that the inventor of the ballpoint pen was an American tanner who, in 1888, connected a little roller ball to a tube of ink to mark his hides.

The quintessential *Bic*®

But because he failed to patent the invention, the person who went down in history as the true inventor of the ballpoint pen was the Hungarian *Ladislao José Biro*, who also put it on the market for the first time.

However, at that time, ballpoint pens were expensive and exclusive. They were only for wealthier people until, in the fifties, the French inventor and industrialist *Marcel Bich* began marketing the famous *Bic*® pens, a brand of ballpoint

During the fifties, artists such as *Andy Warhol* and *Alberto Giacometti* used the ballpoint pen as another medium in their artistic creations.

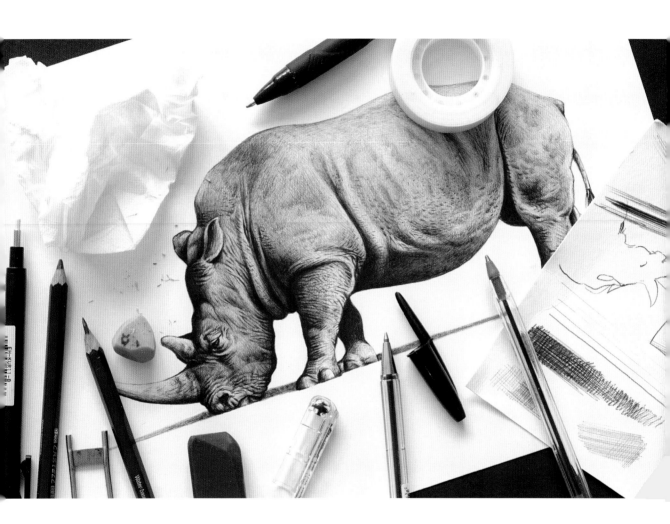

pens that currently sells by the millions across the world each year.

A revolutionary invention
The appearance of this practical, clean and comfortable pen heralded a great revolution, as it allowed people to write without wetting or refilling ink pens. But beyond its use for writing, which was the reason for its creation, the ballpoint pen is used nowadays by artists across the world both to illustrate and to create artworks.

Ballpoint pens and art
During the fifties, artists such as *Andy Warhol* and *Alberto Giacometti* used the ballpoint pen as another medium in their artistic creations.

Currently, many contemporary artists use it as a visual medium, including the magnificent Korean artist *Il Lee*, who creates spectacular large-format abstract works; *Lennie Mace*, *James Mylne*, *Juan Francisco Casas* and *Samuel Silva,* among others, are recognized for their great technical skill and innovative ability with it. ∎

4
Ballpoint pen

Rhino skin
The rhino has a characteristic skin that is rich in shades, wrinkles and fine imperfections that will help us to venture into the world of textures. Its rough and harmonic volumes make it the perfect model for exploring ballpoint pen as a technique.

Highly realistic drawings
If we apply the technique correctly, we can use a ballpoint pen to depict emphatic and subtle forms, as well as sharp contrasts and transparencies. As you can see in the sample drawing, the superposing of hatching allows us to achieve a wide range of greys, and through this we can obtain highly realistic drawings.

Pressure and angle
If we turn the pen or vary its position, the ball will act differently, and this will allow us to discover different tones and densities depending on the angle and the pressure that we use when putting pen to paper. Playing with these two options of pressure and angle, and with their many variants, we can obtain surprising results.

The superposing of hatching allows us to achieve a wide range of greys, and through this we can obtain highly realistic drawings.

Method

1_ First of all, we draw the rhino. Trace the drawing on 200 g glossy paper, redrawing all its lights and shadows with closed-contour areas.

1+2_ We will start by drawing parallel lines in a meticulous fashion, being extremely cautious with the pressure applied to create a solid base of a light tone on which the architecture of our illustration will be constructed.

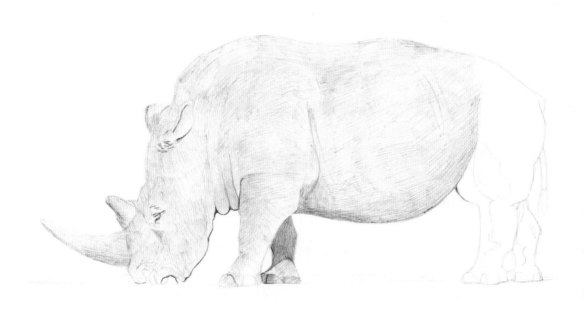

1_

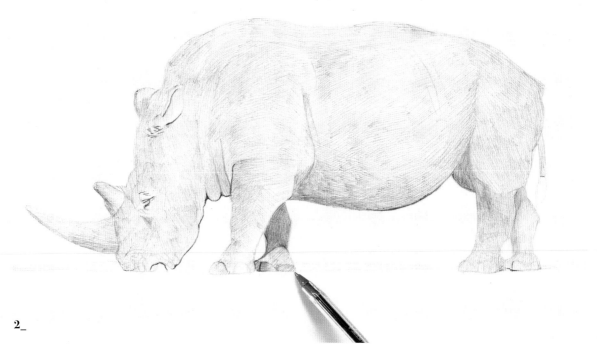

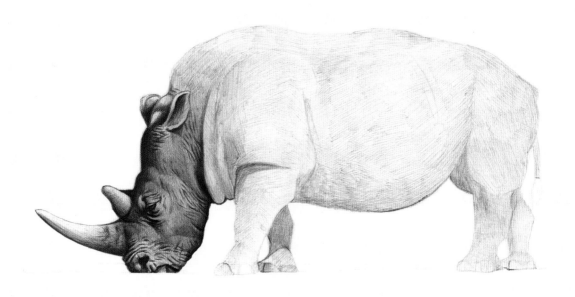

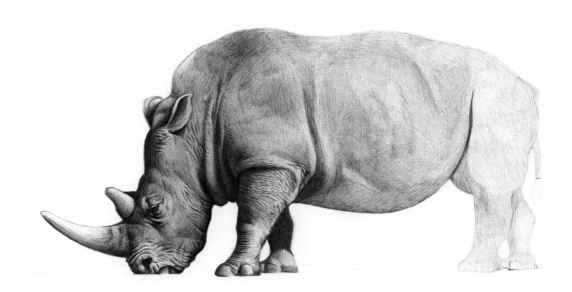

4_

It is necessary to focus and pay full attention to each stroke, working in slow but sure steps. Overshooting would ruin our project, since ballpoint ink cannot be removed easily.

Gel-ink ballpoint pens
Gel-ink ballpoint pens are more sensitive to angles and tend to be more precise. They don't work based so much on pressure, because their ink is more liquid, and so they can move over the surface of the paper more easily.

Durability
The ink from a ballpoint pen stands the test of time. It is only necessary to keep works out of direct sunlight.

Working with multiple ballpoint pens
Having several ballpoint pens on your work table saves you trouble, because after you have drawn a large number of lines, the roller ball loses sharpness and accuracy, giving rise to choppier and dirtier strokes and causing dangerous excesses of ink or drips.

Method

3+4_ Going from left to right (or right to left if you are left handed) so as not to get the drawing messy with our own hand, we will draw darker lines to define the volumes and details of the rhinoceros.

Last step_ We analyse the final illustration as a whole, unifying intensities that have been left uneven. To finish off, we will produce the shadow of the rhinoceros projected on the ground and finish off the drawing.

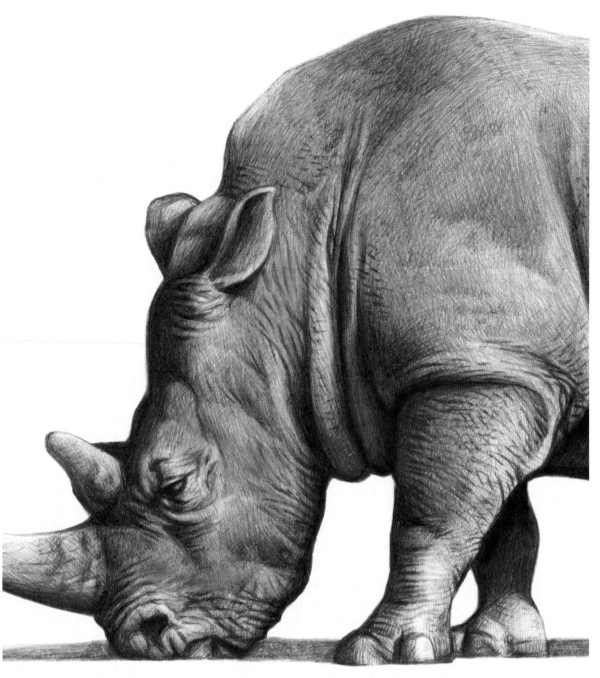



BALLPOINT PEN

53

_Blotting paper
It is important to have blotting paper close to hand so that we can clean the roller ball of the pen frequently, since with the stickiness of its own ink, the tip can get blocked, which makes it lose definition and sensitivity to pressure, creating with the risk of smearing the surface or producing uncontrolled strokes. (◉ **See page 12**)

Having several ballpoint pens on your work table saves you trouble, because after you have drawn a large number of lines, the roller ball loses accuracy, giving rise to choppier and dirtier strokes and causing dangerous excesses of ink or drips.

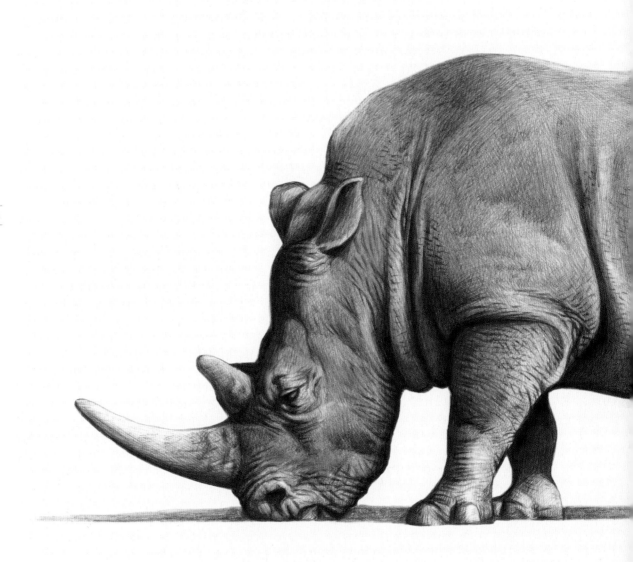

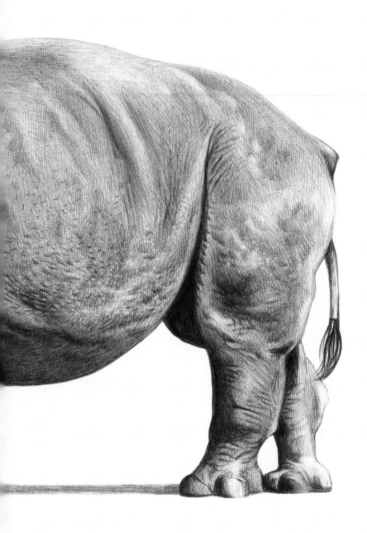

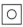

_Glossy support medium
A good support medium for illustration of this type is a glossy paper or one with very little porosity; the ball of the pen will not become blocked on these easily.

Topic 5

INK

Ink

The commonest and best-known ink is probably India ink, which is indelible and lasts permanently.

A LITTLE HISTORY

Although we do not know exactly in which year ink was invented, its origin dates back to ancient China (400 BCE). At that time, ancient Chinese masters were already using black ink (atramentum), composed of *carbon black* (a type of pigment) and rubber, to write calligraphy and draw with quills or brushes.

From then until today, it has always been a part of every culture and has evolved.

India ink

India ink is probably the best-known type of ink and the one used by most of us. It is characterized by its indelibility and permanence over time. It gives us strokes in a very intense black with a slightly shiny finish. If we mix it with water, we can achieve different grey tones. It is not advisable to use it in fountain pens, since it could block them because of its density.

Sumi ink is made from a mixture of pine soot, vegetable oil, bones and glue, and it is prepared according to a traditional method that dates back to more than two thousand years ago.

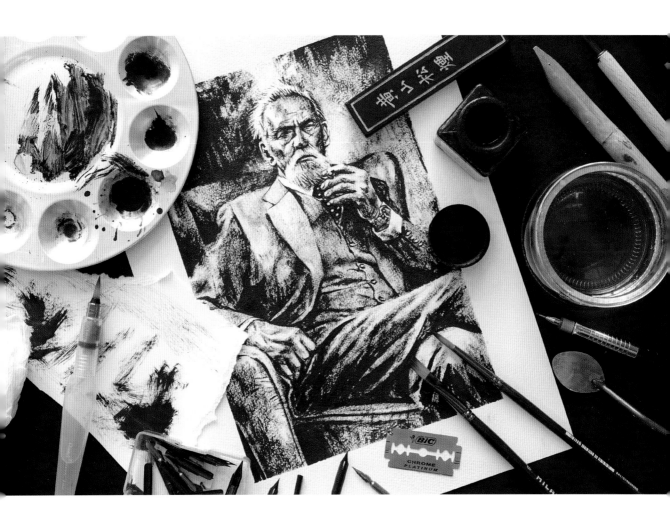

Soluble ink

The advantage of the water-soluble ink is that, once dry, it can be reactivated again by wetting it with water. This ink is appropriate for working with a nib pen or fountain pen, but its main disadvantage is that it is not permanent and loses intensity when exposed to light.

Pigmented inks

These inks are resistant to light, and therefore they are very long lasting.

Sumi ink

We can find this in both bar and liquid form, and it is the ink used for painting *Sumi-e* or *Suiboku*, a monochrome drawing style originally from China that was introduced to Japan in the mid-fourteenth century by Zen Buddhist monks and grew in popularity until its heyday during the *Muromachi Period*.

Sumi ink is made from a mixture of pine soot, vegetable oil, bones and glue, and it is prepared according to a traditional method that dates back to more than two thousand years ago.

It is said that sumi ink, just like wine, improves with time and matures over the years to acquire a blacker and more beautiful tone, making it an ink with a unique softness and richness. It can also be used with a brush, nib pen, fountain pen, bamboo, branches and so on. ∎

5.1
Brush:
Variable stroke

Elegance

In this chapter, we will work with India ink and a brush to produce a portrait of a distinguished gentleman sitting in an armchair. I have selected this image because I believe that elegance is the feature that best defines India ink. This material has a variety of applications and offers us so many graphical options, and so there is always more to explore. In this case, we are going to make an illustration with an aesthetic that is very widely used in the world of comics. A great master of this technique is the renowned comic writer and illustrator *Frank Miller*, an artist who is among the best at binarizing images and whose works characteristically feature ink applied without shade, at 100 per cent of its opacity. This creates complicity with the whites of the images, which always play a very important role. (👁 **See pages 94, 104 and 110**)

The infinite options offered by the application of this technique make for a challenge and an exciting experience.

Method

1_ We will draw the portrait and trace it onto a special 250 g glossy paper for ink.

1+2_ With fine and round no. 2 and no. 4 sable-hair brushes, we will ink the more delicate strokes and profile only the black areas.

Last step_ Use a no. 6 sable-hair brush to fill the interior of the profiled areas. Finally, we will go over the black areas again so that they are totally opaque and then finish off the drawing.

A great master of this technique is the renowned comic writer and illustrator *Frank Miller*, an artist who is among the best at binarizing images.

1_

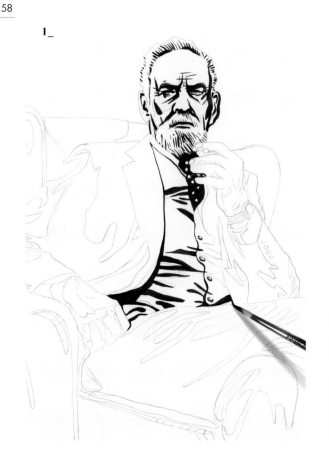

2_

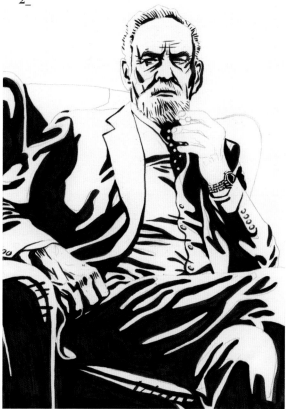

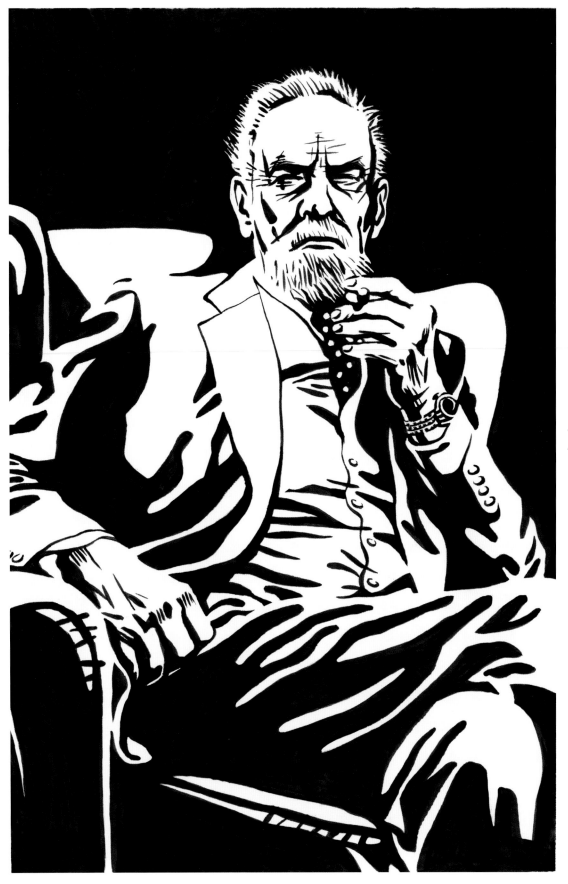

5.2
Brush;
Dry strokes and scraping

Dry strokes

We will now explore ink applied with a dry brush. Since my childhood, I have been a big fan of this technique, which I have practised constantly over the years, since aesthetically it has great conceptual weight and a real power of abstraction due to its "imprecision," which is achieved through splashes of ink, rich and unpredictable contrasts of tone and fine multidirectional strokes, which provide a lot of personality to portraits and an aura of mystery to landscapes.

Old brushes

To execute this technique, we will use old and blunted brushes—if possible, sable-hair ones, as these will allow us to have more control over the strokes.

Old brushes, a knife and a razor blade will be part of our materials

To erase or retouch any imperfections in our application of the ink, we can use a razor blade, keeping in mind that we need to scrape parallel to the paper and do so very softly.

Some examples of different types of brush tips.

We can use different types and formats of ink.

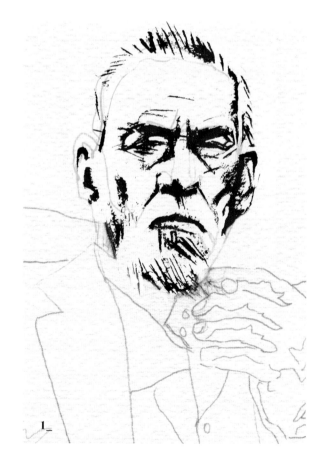

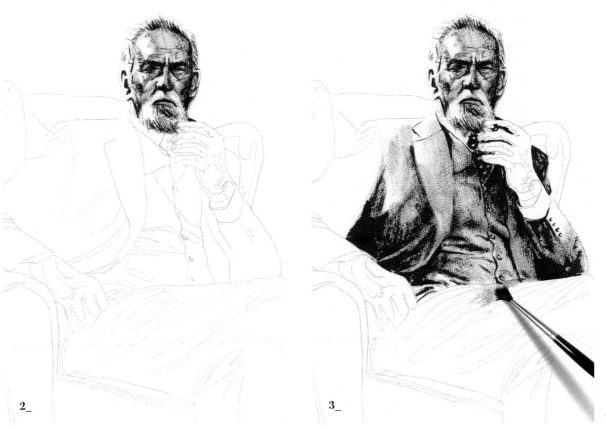

2_

3_

_Dino Battaglia
This Italian comic artist, the undisputed master in the use of ink applied in dry strokes, created his own style out of *The Golem*, in which illustrations defy the panel format, breaking out of its margins.

We will apply the ink via dry strokes over the paper with an old brush. With just a little ink and the brush almost completely dry, we will get light grey tones. With more ink and a wetter brush, we will get darker greys.

_Scrap paper
It is important to always have some scrap paper on our work table (if possible of the same type as the paper that we are using). Each time we take our brush out of the inkwell, we do test strokes on the scrap paper to remove excess ink and moisture before we apply the brush to our work.

Method

We will draw the portrait and trace it with a soft pencil (2B) onto a special 300 g smooth paper for ink.

1_ We begin with the face, drawing some fine ink strokes to subtly imply the nose, mouth, eyes, ears and so on. These lines will serve as a guide for our later application of the dry brush over them.

2+3_ Once the strokes are dry, we will apply the ink gently with an old no. 2 brush. The almost dry ink will not produce much of a stain, resulting in light grey tones.

QR Video
Scan the code to see a small sample of the application
of ink with dry strokes.

Method

3+4_ When painting, we will use energetic but controlled movements, trying to change the direction of the strokes to harmonize the textures we are creating.

4_ Gradually, and going from light to dark, we will work on all the areas of the illustration, leaving the darker areas or almost black ones for the end.

Last step_ We will finish the drawing by darkening the background with a more intense black, producing more contrast and depth.

Each time we take our brush out of the inkwell, we do test strokes to remove excess ink and moisture before we apply the brush to our work.

_Scraping
You can try out the scraping technique with completely dry ink. This involves scraping our work with a sharp object (a knife, awl or razor blade) to create new lights or textures, giving the picture a more energetic look.

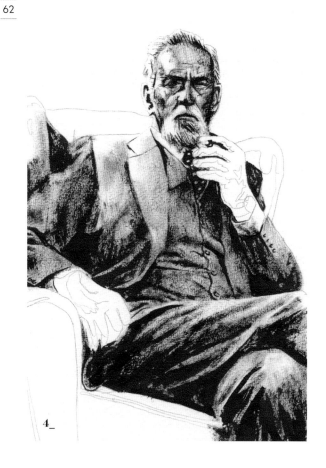

4_

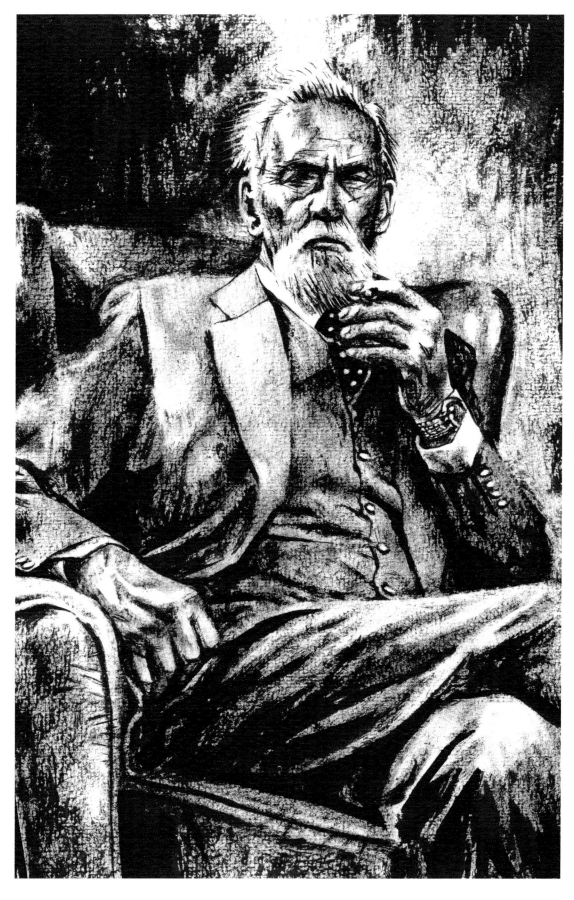

5.3
Brush:
Washes

Ismael's photo
This time I have chosen to depict a photo that the photographer *Ismael Rosales* took some time ago of a mutual friend, the Mexican actress *María Fernanda Tosky*.

The image is perfect for working on the wash technique, since it has some elements that will help us to practise this approach. First of all, there is the hair, an element that is always difficult to get right but will almost inevitably appear in portraits. We also have the fabric of the clothing, an important element for working on volumes, and therefore on a range of greys. In the centre of the image, the face, which

is very well defined, will require us to refine the details. And finally, there are the buttons on the jacket, which will help us work on glare from metal.

What is the wash technique?
The wash drawing technique involves diluting the ink with water. Different intensities and a variety of shades are achieved by diluting the ink with a greater or lesser amount of water. Washes are usually applied with a brush and generally on thick watercolour paper, as this is more water resistant and warps less easily.
(See pages 12 and 78)

_Water-soluble graphite
We could also make this artwork using water-soluble graphite.
(👁 **See page 18**)

_Dana Trijbetz
Using her characteristic ink-wash style and a rich range of greys, this Sydney-based artist produces illustrations of animals, flowers and nature as well as portraits.
www.danatrijbetz.com

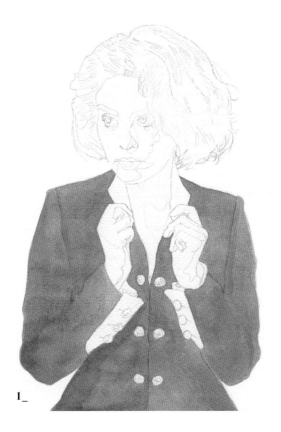

1_

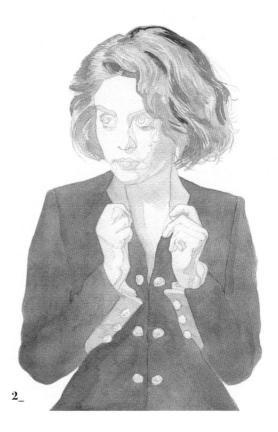

2_

We will change our water regularly so that it is always clean. This way, the grey tones that we have created in the mixing palette will not change.

Method

1_ We will draw the portrait of our subject. We will then trace the drawing on a **250** g medium-grain watercolour paper with an H pencil, redrawing the profile and all the lights and shadows of the image with closed-contour areas.

1+2+3+4_ Gradually, going from light to dark and using a **no. 2** sable-hair brush, we will apply the ink wash in layers, taking care over the dry parts. Each layer applied will increase the tone of the previous layer, darkening it and raising the intensity of the drawing little by little.

The ink-wash technique requires you to work in a gradual way, increasing the intensities of greys and blacks gradually, from the lightest tones to the darkest.

_Blotting paper
When using techniques involving liquids, it is essential to have blotting paper to hand. (I always keep some in my left hand throughout the process, just in case.)

With the blotting paper (you can also use a piece of kitchen paper or something similar), we absorb excess moisture from the brush before application, or once the wash has been applied to the paper.

3_

4_

Mixing palette
The wells of a mixing palette (👁 **see page 90**) will help you organize the ink washes and separate them according to different tonal intensities.

Paper
So that the drawing is more of a departure from the original photograph and has its own personality, I have chosen a medium-grain watercolour paper that will lend artistic character to the portrait.

Ink wash allows us to work in detail and produce very precise finishes for hair, facial details, fabrics, metallic elements and so on.

We will work little by little, without haste, calibrating each brush stroke and testing each grey tone on an extra piece of paper before applying it definitively to the original.

Method

Last step_We will finish the drawing by defining and enhancing the darker blacks and going back over, with a no. 1 brush, the profiles of all the elements to obtain an image with greater focus, detail and definition.

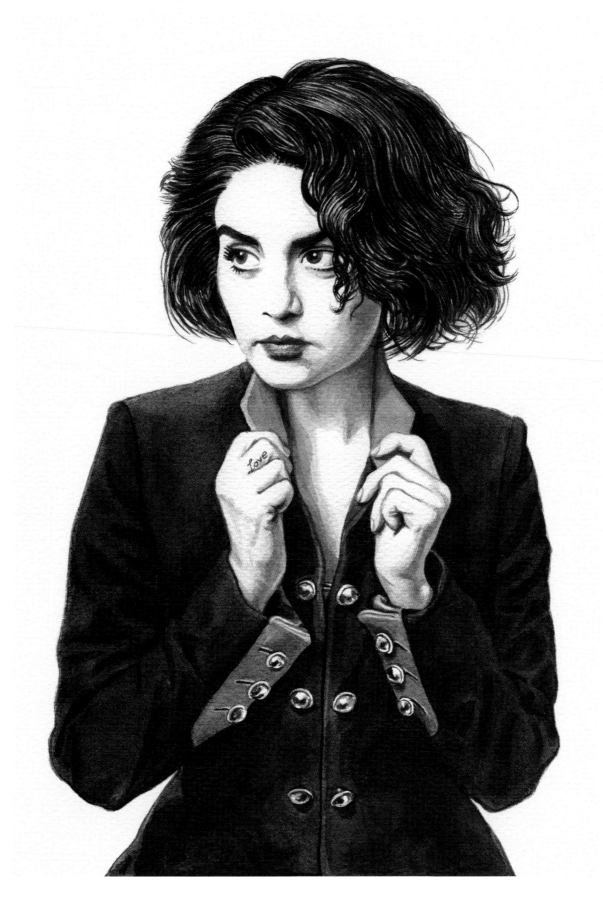

5.4
Nib pen

The olive tree
The olive tree was created to be drawn using a nib pen. The rhythm of its silhouette profiled through lines, its crown captured with pointillism, its twisted trunk scored by black lines: everything about it invites us to wet our nib in ink and start drawing.

The nib pen
A nib is a small metal tip with a cut in the middle. It is fixed at the end of a handle. By exerting pressure on it, the tip opens slightly and releases ink, producing lines of different thicknesses based on the angle and the type of pressure applied. There are tips of many types: thinner or thicker ones;

flexible ones; double ones; steel, glass or gold ones; and so on. The ones most suited to drawing have a straight or oval tip. Curved, flat or short ones are designed more for calligraphy.

Hatching with personality
Hatching made with a nib is organic and has great depth and character.

In contrast to markers, the stroke from a nib is always variable, and therefore the lines are not exactly the same as one another. This makes the nib pen a masterful tool for the hatching technique. (👁 **See pages 31 and 98**)

Method

1_ We will draw the olive tree and then trace it using a light box on a special 200 g glossy paper for ink.

1+2_ Next, produce short lines of different thicknesses to create hatching that depicts the leaves of the olive tree.

3_ We will now work on the trunk using some parallel lines and other lightly crisscrossing ones, following the trunk's curvature, to render the different volumes of wood.

Last step_ To finish, we will rescue some of the whites using gouache on the black of the base of the trunk and the white leaves of the fennel in the foreground.

INK

68

1

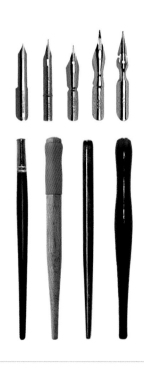

We can choose between different nib-pen tips and handles.

2_

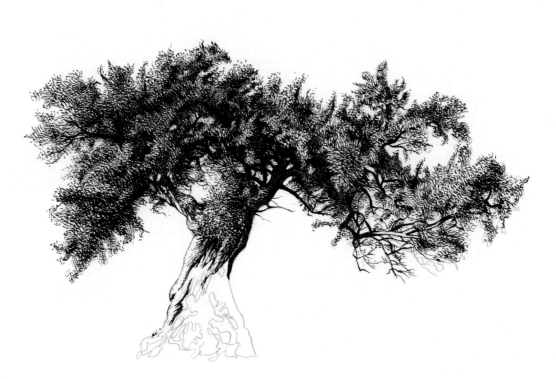

3_

QR Video
Scan the code to see a small sample of
how a nib pen can be used.

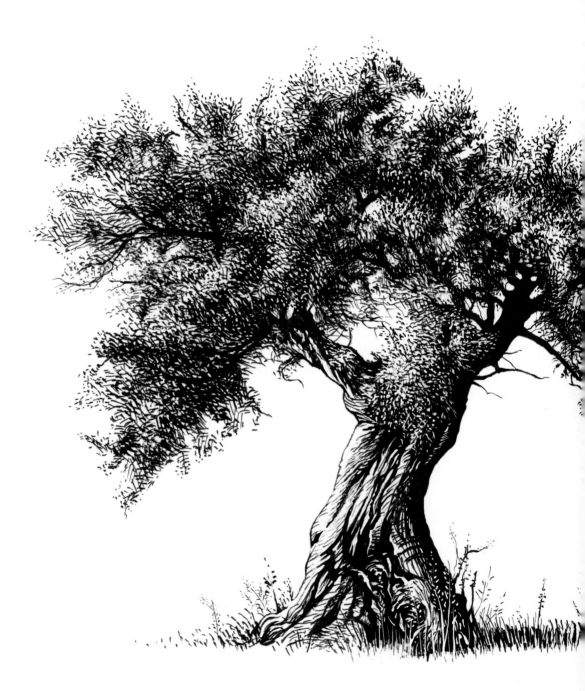

The nib pen is an instrument that it takes time to get used to.
It is necessary to get acquainted with the way in which it holds the ink and the pressure and the angle that must be used against the paper.

_The light box
As with the other techniques, you can also try to trace the initial drawing directly on the paper with a nib pen by using a light box. This lets you correct mistakes made when tracing and have a clean original, without having to erase residual pencil.

5.5
Bamboo

We'll always have Venice
I love drawing cities with bamboo: the intersection of planes, the graphical jumble of its lines and the abstraction that its strokes produce are ideal elements for depicting urban portraits of cities such as Venice.

Bamboo
The tradition of the drawing with bamboo comes from ancient eastern art and has endured to the present because it is a delicate and characterful technique.

Although bamboo does not allow for the kinds of modulations that you get with a metal-nib pen, its stroke is richly expressive. By varying the pressure and the amount of ink used, we can achieve very different results. Another possibility that increases your options is to work with ink washes, which enable not only the use of intense and opaque blacks, but also gradients of different grey tones.

Drawing with bamboo is a properly artistic experience; it has peculiar characteristics at both the stroke and conceptual levels, so it is important to let go and not be afraid to try things out.

And, of course, given the freshness of its strokes, it is an ideal instrument for sketching.
(👁 **See pages 13 and 74**)

_Dry branches
Drawing with branches is exciting. Depending on the type of wood and its size, we will obtain very different results. We can also

Method

1_We will draw the scene of the Grand Canal of Venice and trace the drawing onto a piece of special **200** g smooth paper for ink.

We then wet the bamboo in ink and begin to draw energetically, taking advantage of and making room for any unforeseen strokes that we might make.

Last step_ We finish the sketch with a little retouching done with broken sticks wet with ink.

sharpen the tips of the branches with a knife to get more precise and cleaner strokes.

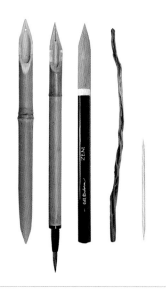

We can choose between different types of bamboo or use branches or sticks.

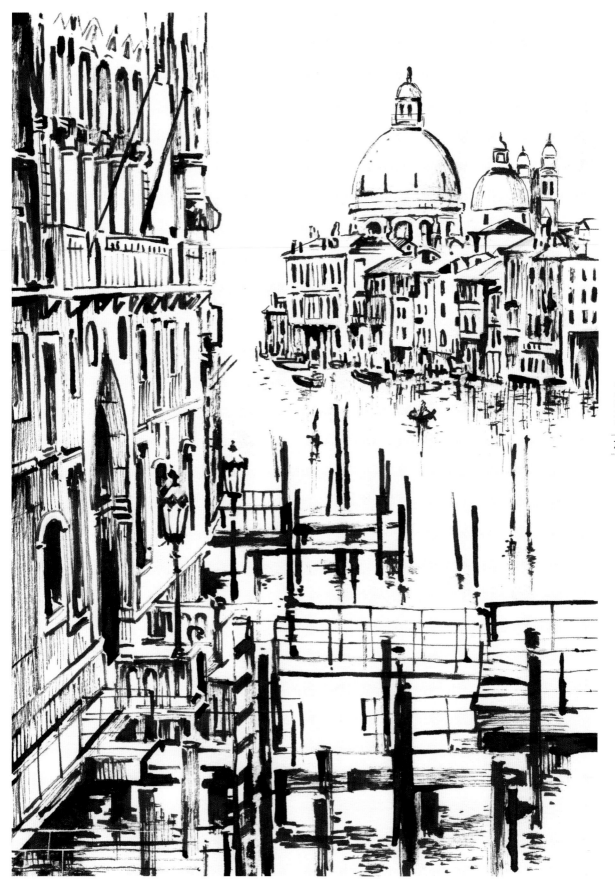

5.6
Fountain pen

Beyond writing

Anyone who has tried using a fountain pen knows that writing with one goes beyond mere writing; the feel against the paper, the elegance and its stroke bring added value to this common and frequent act. However, the potential for using a fountain pen with various types of ink and nibs that offer different visual possibilities also makes it a unique instrument for drawing.

Sketching with a fountain pen

The advantage of a fountain pen over a nib pen is that, with a payload of ink inside the pen, you can draw with it anywhere, and so it is very convenient for in

The advantage of a fountain pen over a nib pen is that, with a payload of ink inside the pen, it is very suitable for in situ sketching.

situ sketching. The fountain pen's advantage over ballpoint pens or markers is the possibility it offers to choose your own nibs and inks. (◉ See pages 13 and 72)

The nib

You will find numerous types of nibs or tips: *fude, music, flex, falcon* and many others. *Fude* nibs, for example, have a nib tip that rises upwards, while *flex* nibs are curved. Try out and choose the one you like for each occasion.

Ink

The use of a fountain pen to draw offers us the advantage of being able to choose the ink that we want for each illustration. If, for example, what we're looking to do is draw with washes, we will use an indelible ink that we can apply water to without any smudging. (◉ See page 78)

_Indelible inks
As with India ink, indelible inks tend to be pigmented—that is, they contain tiny dissolved particles that can obstruct the nib. For that reason, if we use inks of this type, it is important to clean our fountain pen on a regular basis.

A fountain pen and a sketch pad are a perfect work kit to always carry around in a backpack.

Pabellón Villanueva
Real Jardín Botánico
Madrid
18 - 9 - 2017

Topic 6

Water colour

The watercolour technique involves painting with semitransparent layers called "washes."

A LITTLE HISTORY

Watercolour began to be used in China shortly after 100 BCE, coinciding with the invention of paper.

The Italian Renaissance

In the twelfth century, the Arabs introduced the manufacture of paper to Spain, and the technology later spread to Italy and France, where we find some of the oldest paper manufacturers, including *Fabriano*® and *Arches*®, in the thirteenth and fifteenth centuries. Probably for this reason, art history, and particularly the era of the Italian Renaissance, is full of magnificent European watercolourists.

The value of transparency

Watercolour is a type of transparent paint that, when diluted with water, allows different tones and transparencies to be produced. It is made of a fine pigment or ink mixed with gum arabic to give it body and glycerine or honey to give it viscosity. We can find it in both

**One of the advantages of watercolour
is that it lets us make corrections by
adding or removing water using brushes,
sponges, cloths or bleach.**

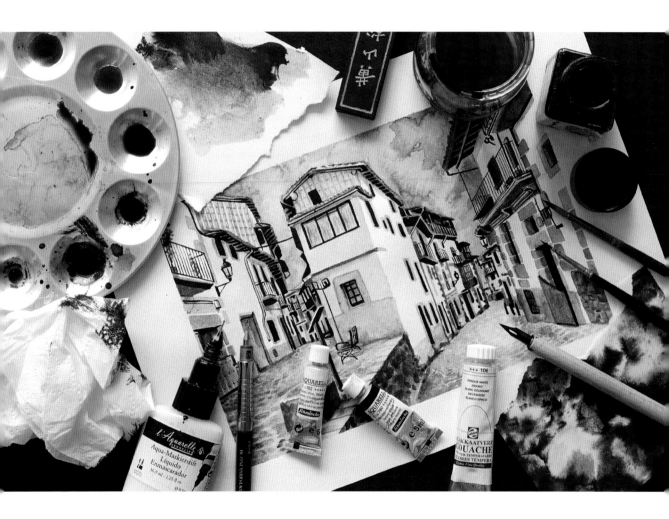

tubes and pans. As with water-soluble inks, watercolour loses intensity if it sits in light.

Technical matters
The watercolour technique involves painting with semitransparent layers called "washes."
Washes are always applied by going from light to dark, and dark tones are achieved through the superposing of several washes. Because there is no white, we must preserve the white of the paper to protect areas of light.

One of the advantages of watercolour is that it lets us make corrections if we add or remove water using brushes, cloths or bleach.

Wet in wet
This technique entails wetting the paper on which we are going to work before we begin. Through doing so, we will manage to bring together different areas by creating a number of very aesthetic patches.

Paper
It is very important to use the right paper for watercolour, because if we do not, the amount of water that we apply could warp and damage the paper. We can also choose the level of the paper's grain, from smoother to more textured, depending on the effect that we seek. (⊙ See page 12) ∎

6.1
Watercolour and India ink

Close, but not that close
An image of the village of *Candelario* in the province of Salamanca (Spain) on a rainy day is a perfect scene for working with this mixed technique, which brings together but does not mix ink and watercolour, in this case (of course) black watercolour. I have chosen this image because of the balance between very well-defined small details (the bars of the balconies, electricity cables and so on), which will be rendered in India ink, and the larger areas (for example, cobblestones and the stormy sky), for which watercolour is perfect.

India ink and water
Mixing India ink and watercolour is a widely used technique in the visual arts for one big reason: India ink is indelible and will not be smudged by water. And so we can draw in ink, and once it is dry, we "colour" the illustration using watercolour; the water will not have any effect on the previously painted areas.

Watercolour paper
Watercolour paper is the most suitable choice for working with this technique, as it copes with water and the warping that moisture can cause much better.

As I mentioned earlier, the heavier the paper, the better it will tolerate moisture and the less it will become deformed. (👁 **See pages 12, 18 and 64**)

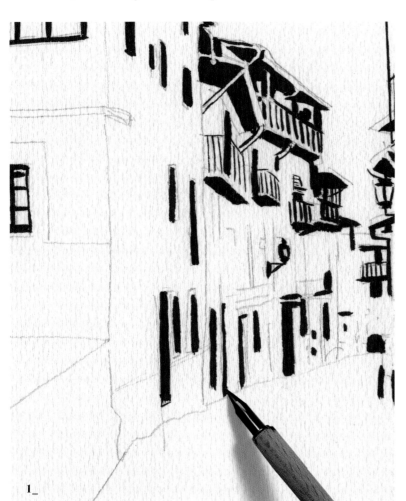

1_

Watercolour allows us to achieve homogeneous and delicate gradations.

✳

_How to prevent curling
To stop the paper curling during the working process, it is advisable to moisten it and tauten it beforehand by, for example, pasting it against a rigid surface at the edges.

India ink is indelible, and water will not smudge it. And so we can draw in ink, and once it is dry, we "colour" the illustration using watercolour; the water will not have any effect on the previously painted areas.

_Elicia Edijanto
According to this Indonesian illustrator, "Using only black watercolour (mostly), I try to create unique relationships between humans and nature. My subjects are often children and animals because they are honest, sincere, unprejudiced and unpretentious... They give me so much inspiration for particular moods or atmospheres, such as tranquility, solemnity and also wildness and freedom, which I put in my paintings."
www.eliciaedijanto.com

Method

We will draw this village scene on a sheet of paper, marking out the lights and shadows. We then trace it with a B pencil on an approximately 200 g, medium-grain watercolour paper.

When you draw, it is important to not exert much pressure so that you do not damage the watercolour paper, as it is very sensitive and can easily be marked with small furrows that prevent ink or watercolour from being applied to it properly.

1+2_ First stage: India ink
We will begin to draw with ink, using a nib pen or a no. 1 sable-hair brush. In this case, as you can see, I've started by drawing the darker areas of the scene such as the bars of the balconies, some of the doors, windows, the bench and pipes—in short, fixed details that we do not want the water to deform when we apply the watercolour.

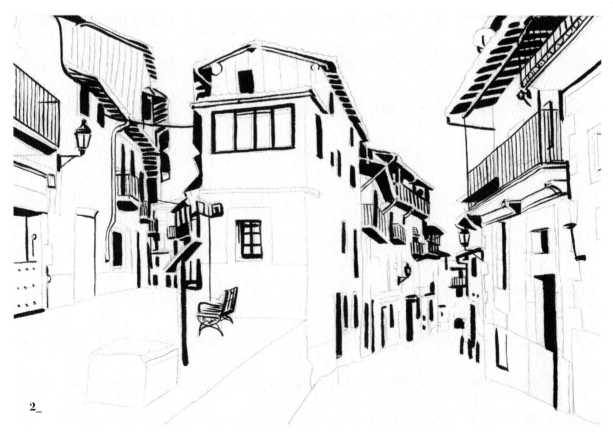

2_

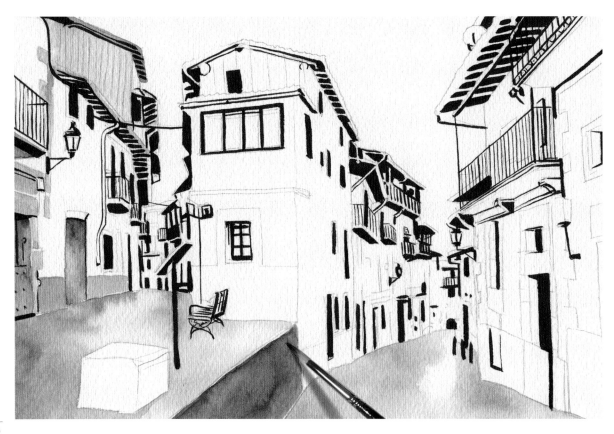

Method

3+4_ Second stage: Watercolour
Wait until the ink has dried completely, and then apply the watercolour in a gradual manner. Working from light to dark, we will apply it in layers; each layer will increase and darken the tone of the previous one.

Always apply watercolour from left to right (or from right to left if you are left handed) so as not to mess up the wet areas with your hand.

Last step_ We finish the illustration using opaque white gouache to retouch and bring light to any areas or details of the drawing that we want to highlight or lighten.
(See page 88).

Wait until the ink has dried completely, and then spread the black watercolour in a gradual fashion and working from light to dark, applying it in layers.

※

_Hairdryer
If you want to accelerate the process of drying ink, watercolour or paper and work more quickly, you can use a hairdryer.

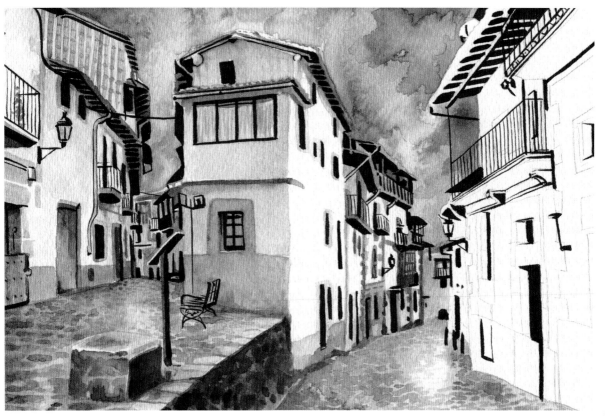

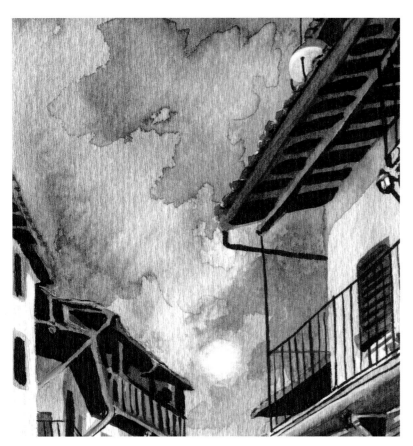

_Also try

To create textures such as the ones we see in the detail of the sky, once the area is dry, we will partially remoisten it with a few drops of watercolour and plenty of water. You will see that, when it dries, this new overlapping patch will have created a texture with very interesting contours.

The commonest way to use watercolour is to preserve the whiteness
of the paper for light parts and gradually paint from light to dark,
applying layers or "washes" of transparent colour.

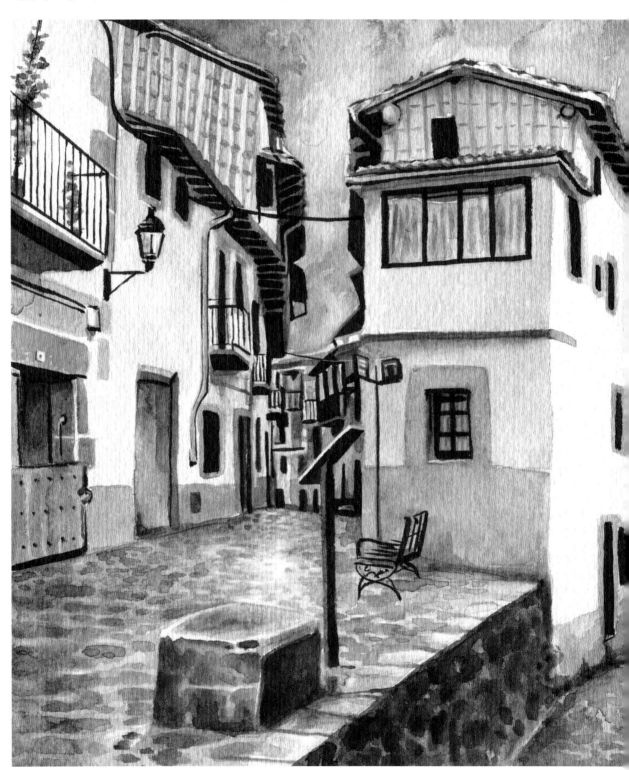

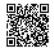

QR Video
Scan the code to see a small sample of how
watercolour can be applied over ink.

_Cotton buds
To rescue very light parts, you
can soak up wet watercolour
with cotton buds.

QR Video
Scan the code to see a small sample of the
effect of bleach on aniline.

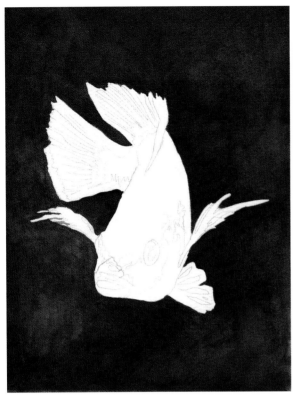

1_

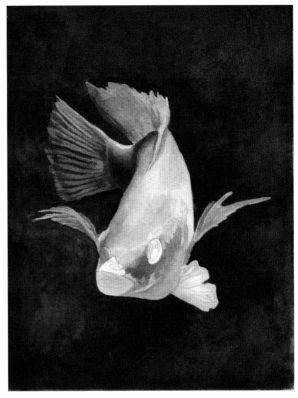

2_

6.2
Aniline and bleach

It's all water
The fish's habitat is water, and
so is liquid watercolour's. In
fact, liquid watercolour is water
with colourants.

Based on this association of ideas,
fish came to my mind to poten-
tially play the lead in this section.
The fish is surrounded by water
and generally lives in semidark-
ness, and that's why I think it
would be interesting to rescue it
from that darkness and bring it
closer to the surface, illuminating

it through applying bleach,
which, as you will see, is magical.

Pros and cons
Within the various types of
watercolours, liquid ones are
more fluid and brighter. Liquid
watercolour is made out of
water and high-concentration
colourants, and this is why
it is the best product for
airbrushing, since it does not
contain pigments or bases that
can clog valves. However, it is
not light resistant, so it is more
suitable for projects that are kept
away from lit areas or that will
subsequently be scanned.

_Night on Bald Mountain
In 2013, the Spaniard *Miquel Bar-
celó* and the Frenchman *Michel Bu-
tor* published an exceptional book
in a limited edition of ninety-nine
copies with *Éditions de La Dif-
férence.* Barceló provided drawings,
while Butor contributed poems.

The project began after *Barceló*
took a trip to a volcanic island and
returned with a notebook painted
with bleach. Or rather, what he
did, as the artist himself says, was
"stripping paint with bleach," since
the technique involves making
forms emerge out of a black back-
ground. His intriguing drawings
inspired *Michel Butor* to write the
series of poems that makes up the
rest of the book.

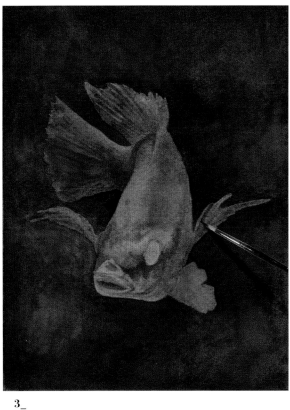

3_

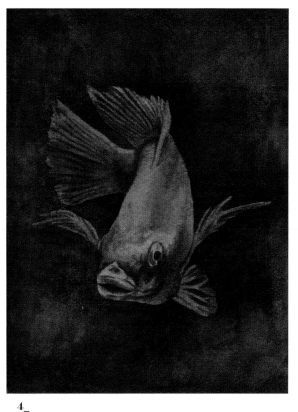

4_

I have used the bleach to illuminate and give prominence to our fish, rescuing it from the drab darkness in which it dwelt.

_Bleach
Using bleach is not a particularly accurate process; if you need more control and definition, I would recommend that you work with masking fluid to preserve the white of the paper. (See page 90)

Method

We will draw the scene in pencil and trace it with a B pencil on a special 250 g untextured watercolour paper.

1 *_ We will paint the seabed with a no. 6 sable-hair brush using a fairly but not entirely uniform dark grey to create a sense of depth.

2+3_ We will start to work on the fish and proceed to increase its tonality, following the order of light to dark and using a no. 2 brush.

It is worth my commenting that another, just as valid process would be to paint the fish first and then do the background.

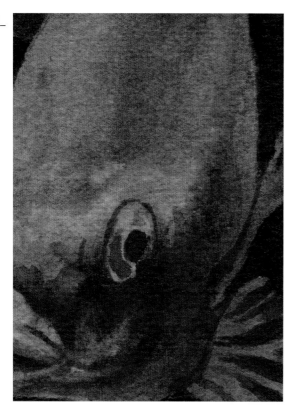

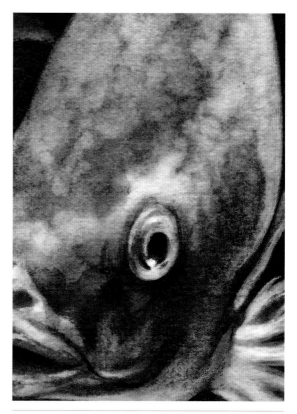

Detail of the image before the bleach is applied.

Detail of the image with the light effect from the bleach.

To apply the bleach, it is advisable to use cheap or old brushes, since its corrosive action destroys the bristles' fibres.

Bleach and light

Bleach is a material that has surprises in store for us if we apply it to nonindelible inks or watercolours. As anyone who has tried to use it on their favourite pair of jeans knows, bleach creates discolouration. That is exactly what happens when we apply bleach to watercolour. It literally "eats" it. If properly controlled, this use for bleach can be very helpful, as it lends very interesting graphic effects to our works.
(👁 See page 46)

It is also necessary to keep in mind that bleach develops a yellowish tone, but if we want our drawing to be purely black and white, all we have to do is scan and convert the image to greyscale.

Method

3+4_ Since this is an image in semi-darkness and with little contrast, we will darken the fish, bringing it together with the background and working in layers, so that each layer darkens the tone of the previous one.

5_ With a no. 0 brush of the same quality as the previous ones, we will define the finer details of the fish to finish it.

Last step_ We will apply the bleach with an old no. 3 brush to "illuminate" the fish. We will respect its volumes and its form to achieve an unsettling image that flits between light and shadows.

_Durability

Liquid watercolour is not light resistant, so it is more suitable for projects that are kept away from lit areas (ones that will not be displayed, for example) or that will later be scanned.

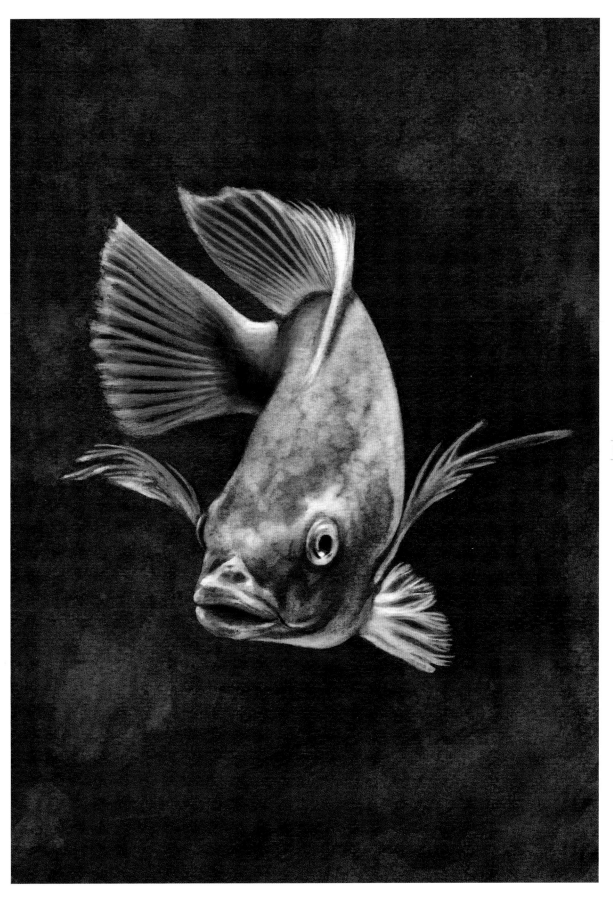

Gou ache

This medium was used to illustrate manuscripts in the Middle Ages, and it is still very widely used by contemporary artists.

A LITTLE HISTORY

The inventor of gouache, or tempera, was probably an eleventh-century Italian monk who began to add zinc white to the watercolours that were used to illustrate manuscripts.

This is why we can say that gouache is a kind of opaque watercolour that contains a higher quantity of binders that provide it with a smoother and creamier consistency.

The great masters

This technique was used to illustrate manuscripts in the Middle Ages, and in the seventeenth century, many European masters such as *Van Dyck*, *Gaspard Poussin* and *Van Huysum* also used it to produce their artworks. Later, just like watercolour, gouache became very popular in England in the late eighteenth century, especially among the great landscape painters of the day. In the early twentieth century,

Among gouache's benefits are the quickness with which it dries and the variety of its applications to different support media such as paper, cardboard, wood and canvas.

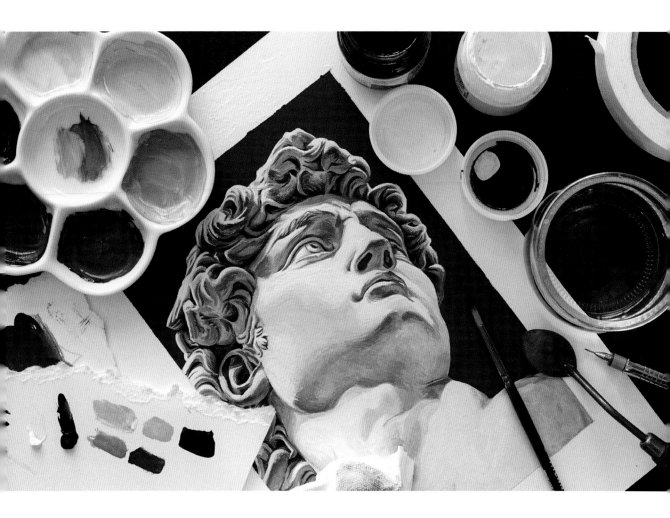

Joan Miró also used gouache for his surrealist creations, and this technique is still widely used by contemporary artists today.

Opaque watercolour
Because it is an opaque paint, gouache can be applied both in smooth base layers of colour and in more gestural and expressive brush strokes. However, it is advisable to always apply it in thin layers, since the paint tends to crack if it is applied too thickly.

Among its benefits are the great quickness with which it dries and its variety of applications to different support media such as paper, cardboard, wood and canvas.

Paper
Generally, smoother papers than those for watercolour are used, since the paint flows more smoothly on glossier papers.

Brushes
Choosing a good brush is very important when it comes to gouache. The most suitable brushes are sable-hair ones, but today we can also find cheaper synthetic brushes that are of very good quality in any shop specializing in fine-arts supplies. (◉ See page 60) ∎

1_

2_

7
Gouache

David and Goliath
Michelangelo's David: a Renaissance masterpiece. The young shepherd *David* in the moments before his confrontation in the Bible with *Goliath* the giant. In my opinion, the personification of genius.

Drawing from real life
It would have been nice to have been able to go to the Galleria dell'Accademia in Florence, where this magnificent sculpture is currently on display, and do the first sketches to illustrate this section in situ. But it was a bit far away, so I have chosen to work based on photos. However, I encourage you to draw from real life whenever possible, as it is a rewarding and very instructive experience.
(👁 See pages 13, 72 and 74)

A

Figure A
A white porcelain palette will allow us to mix the grey tones with greater accuracy.

Method

We will draw the sculpture's torso. We will then trace the drawing on a 350 g fine-grain watercolour paper with an HB pencil, redrawing the profile and all the lights and shadows of the image with closed-contour areas. This will give us a guide and make it easier to place lights and shadows when we apply the gouache later on.

_Drying gouache
When we are working, it is important to take into account that gouache tones tend to darken a bit once dry, especially the darkest ones.

3_

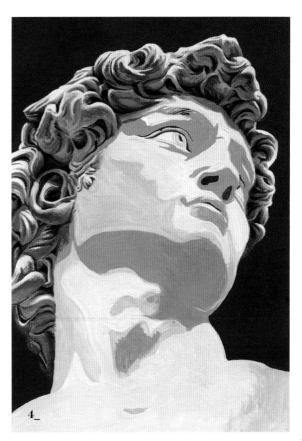

4_

Using a mixing palette and plenty of paint, we will create an achromatic range of different greys and use it to render practically all of our illustration.

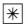

A_In our mixing palette, we will create (using plenty of paint) an achromatic range of grey tones and use it to render 90 per cent of our illustration.

1+2+3_We will create the "base" by placing each grey in the corresponding area in accordance with how light falls on the sculpture. In the more luminous areas, the greys that we will use will be lighter, while in the less illuminated areas, they will be darker.

4_ Once all the tones are in place, we will begin to work on each area with a uniform layer. We won't let the paint dry so that we can mix the greys in a malleable fashion, which will produce softer gradations and more precise finishes.

_Masking fluid
This is a viscous liquid that allows us to keep particular areas of our works untouched. Having previously applied the product to the paper, we will be able to paint with total peace of mind and ensure that the white of the paper remains untouched. We will apply it on dry paper and let it dry completely before painting over it. Once the paint has been applied as desired, we will be able to remove the masking by rubbing it lightly.

5_

6_

The mixture
It is important to prepare a lot of paint for each tone, since we need enough of it for the whole process. Better too much than not enough. Preparing more paint later and getting exactly the same tone is virtually impossible.

So that the tone that we have created is completely homogeneous, we must mix it very thoroughly, producing a texture that is neither very thick nor very liquid. We then apply it in thin and uniform layers.

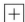

_Acrylic painting and oil painting
This type of illustration can also be done using (water based) acrylic paints or oils. Personally, I really like gouache's silky matt finish.

The grey scale
Greys are achromatic colours whose luminosity falls between maximum light (white) and an absence of light (black).

It is important to take into account that gouache tones tend to darken a bit once dry, especially the darkest ones.

Method

5+6_ If we apply the technique conscientiously, we will be able to obtain highly realistic results in areas such as the hair, eyes, ears and so on.

Last step_ We will finish our David by creating two new tones: the lightest grey and the darkest grey. We will use them to retouch the last contrasts of light and shadow, thus finishing off our illustration.

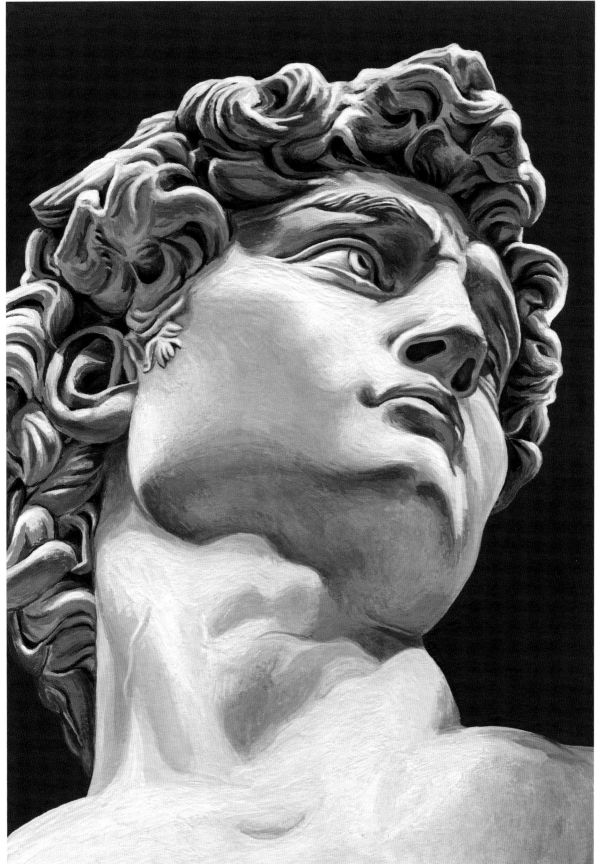

Gratta ge and frottage

German artist *Marx Ernst*, a key figure in both the Dada and surrealist movements, is considered to be the inventor of these techniques.

A LITTLE HISTORY

German artist **Marx Ernst** (1891-1976), a key figure in both the Dada and surrealist movements, is considered to be the inventor of these experimental techniques.

Over the course of his multi-faceted artistic life, this indefatigable creator experimented continuously in search of new materials and artistic methods.

Among others, he invented the techniques of *frottage* and *grattage*.

Grattage

This French-named technique, which was very widely used by the surrealists, and principally by *Max Ernst* and *Joan Miró*, is a method with a great expressive power. It consists of scratching or scraping paint from a canvas or base that

The surrealists often turned to the frottage technique, which they viewed as a starting point for the expression of subconscious images and a stimulus for the imagination.

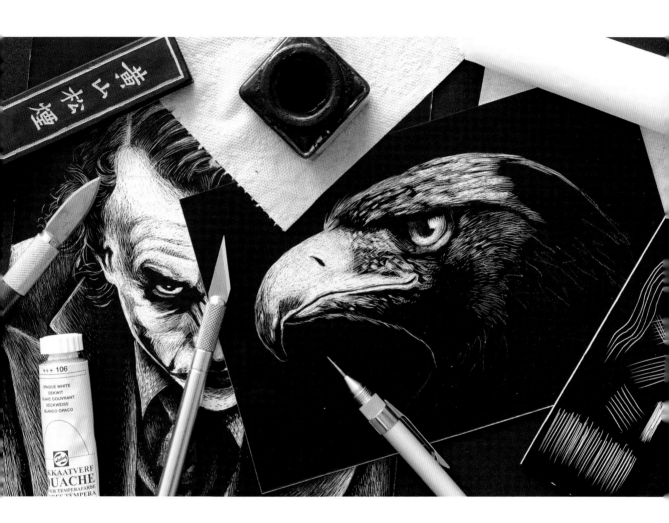

has previously been prepared with several layers of colour (in this case, a layer of white as a base and a layer of black covering it).

Frottage
Over the course of his explorations, *Max Ernst* produced a series of drawings by placing sheets of paper on an old and worn wooden floor and gently rubbing them with a pencil.

The drawings resulting from the experiment really call to mind organic shapes from nature. In 1926, Ernst published some of these drawings under the title *Histoire Naturelle*.

A stimulus for the imagination
Later, the surrealists often turned to the frottage technique, viewing it a starting point for

the expression of subconscious images and a stimulus for the imagination.

Multitechniques
Moreover, these two techniques are themselves "multitechniques," since they can be used with many types of different materials—for example, oils, acrylic, charcoal, wax, graphite and ink. ∎

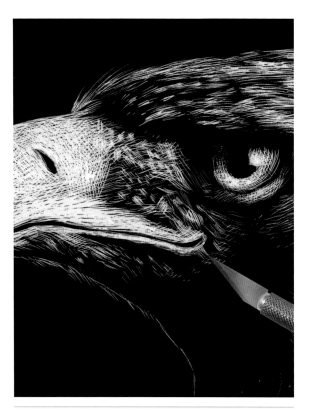

To produce an illustration using grattage, the best thing to do is use a scalpel or an awl, as these will enable us to work with great precision and detail.

To produce an illustration using frottage, we can use graphite, charcoal, wax, oils or any other material that will allow us to "capture" the texture that we are rubbing against.

Sgraffito

Sgraffito is a form of grattage that is performed on a painted surface and based on two superimposed layers that make it possible to reveal shapes or drawings by scraping or scratching at the outer layer.

How to prepare homemade sgraffito in black and white:

1_ We will paint the entire surface of a rectangular piece of white 350 g card with plenty of white oil pastel, trying to cover all the paper's pores.

2_ We then spread a thin layer of flour over the pastel, covering all of the painted surface.

3_ Remove any excess flour with a cloth.

4_ Next we paint the entire surface gently with India ink and a no. 14 flat-tip brush, trying not to sweep away the pastel.

5_ With all the surface completely black and dry, we can now begin to scrape with a scalpel to create our drawing.

To produce a grattage or sgraffito piece, we use a scalpel or an awl that will serve as a pencil to create the illustration out of small scratches.

_Jean Dubuffet
Considered the creator of the art brut artistic movement, this multifaceted French artist produced much of his work in black and white. Particularly worth noting among his pieces is ***Building Facades***, which was produced using grattage (in this case with oil) and is currently on display at the MOMA in New York. In this work, the artist attains full freedom of expression thanks to this scraping technique.

To make this image, I have made use of a commercially produced support for grattage, which consists of a card base prepared with a layer of compacted chalk that is in turn coated with a thin layer of black ink.

1_

8.1
Grattage

Heath Ledger

The *Joker* is a fictional character. He is the antithesis and archenemy of *Batman*, and one of the most influential villains in the history of comics. In 2008, *Heath Ledger* played him in the film *The Dark Knight*, in a memorable performance that won him a posthumous Oscar for best supporting actor, in large part owing to the sinister depth that he infused the character with. It is for this reason in particular that I have chosen this *Joker* to make a picture using the grattage technique.

To make this image, I have made use of a commercially produced support for grattage, which con-sists of a card base prepared with a layer of compacted chalk that is in turn coated with a thin layer of black ink, which is the layer we will be scraping away with a scalpel.

During the scraping process, we must be careful not to exert too much pressure in order not to damage the white inner layer of the cardboard, which should remain untouched.

Method

1_We will make the portrait by taking inspiration from a photo of the Joker, and we will then transfer it to the prepared surface for grattage with the help of white tracing paper.

QR Video
Scan the code to see a small sample
of how grattage is produced.

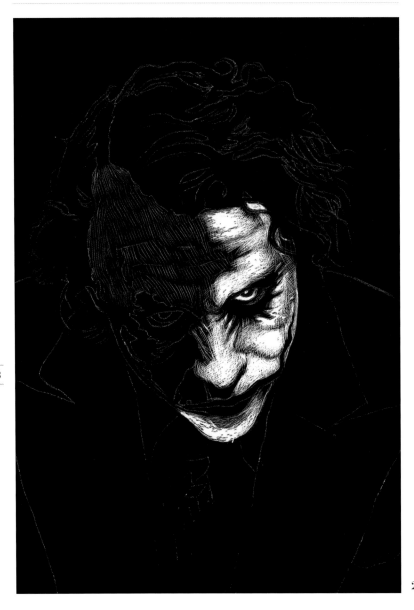

To render the
gradations, it is
necessary to have a
lot of patience and
a steady hand and
to be aware of two
essential factors when
making each stroke:
the pressure that we
apply and the angle
of the scalpel.

2_

_Matias Ercole

This Argentine artist usually draws with needles or knives on a layer, prepared beforehand on paper or cloth, of black India ink that is in turn covered with a surface layer of wax. He "explores the iconography of the landscape in his drawings to share his reflections on the deformation of the natural and the manner in which an image is constructed and conceptualized," creating very suggestive compositions in which the figurative is mixed with the abstract.
www. cargocollective.com/Ercole

_Experiments and tests

We can also experiment with doing grattage with scissors, pins or any other sharp object.

In the case of the frottage, you can also try it with graphite or charcoal powder, applying and rubbing the material directly with your fingers.

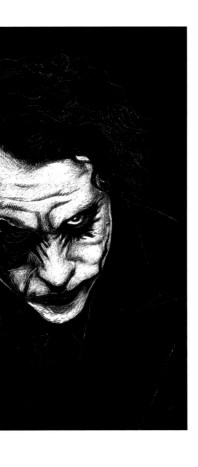

3_

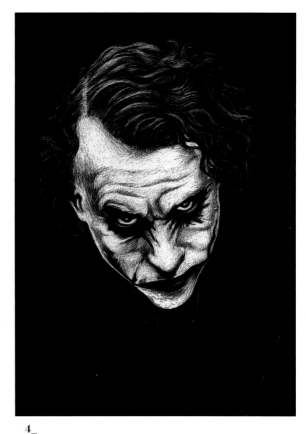

4_

Gradations in Grattage

Using a scalpel as a "scraping pencil" takes time to get used to. In this technique, everything is done based on scraping. You could say that it is like working with a nib pen (👁 **see page 68**) but in reverse. For that reason, creating gradations can be the hardest part of this exercise.

To render the gradations, it is necessary to have a lot of patience and a steady hand and to be aware of two essential factors when making each stroke: the pressure applied and the angle of the scalpel. The higher the pressure, the wider the strokes that we will produce and the more light that we will reveal. At a lower pressure, the strokes will be thinner and there will be less white and less light.

It is important to change the blade of the scalpel fairly regularly so that the grattage strokes are as accurate and clean as possible.

Method

2_Using a scalpel, we will begin to scrape against the black surface to profile the Joker, remembering that it's a negative drawing—that is, the strokes that we usually draw in black will now be white.

2+3+4_We will proceed by scraping to produce hatching, working with the scalpel as though it were a pencil. First we do the lights on the face and then the hair.
(👁 **See page 31**)

During the scraping process, we must be careful not to exert too much pressure in order not to damage the white inner layer of the cardboard, which should remain untouched.

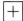

_Experimental method
In this section, I have opted to make a realistic, shade-filled image, to show you the levels of realism and detail that we can attain if we apply this technique well.

However, do not forget that it is an ideal method for experimenting with loose and gestural strokes and creating organic and abstract compositions such as those of, for example, *Matias Ercole*.
(👁 See page 98)

Method

A+B_ Once the face and hair have been defined, we will start, with a lot of patience and constant attention, to detail these two areas on the basis of fine and accurate scratches.

Last step_ Having completed the face and hair, we will work on the body at the same level. To finish things off, we will erase the remnants of the tracing and consider our grattage done.

A

B

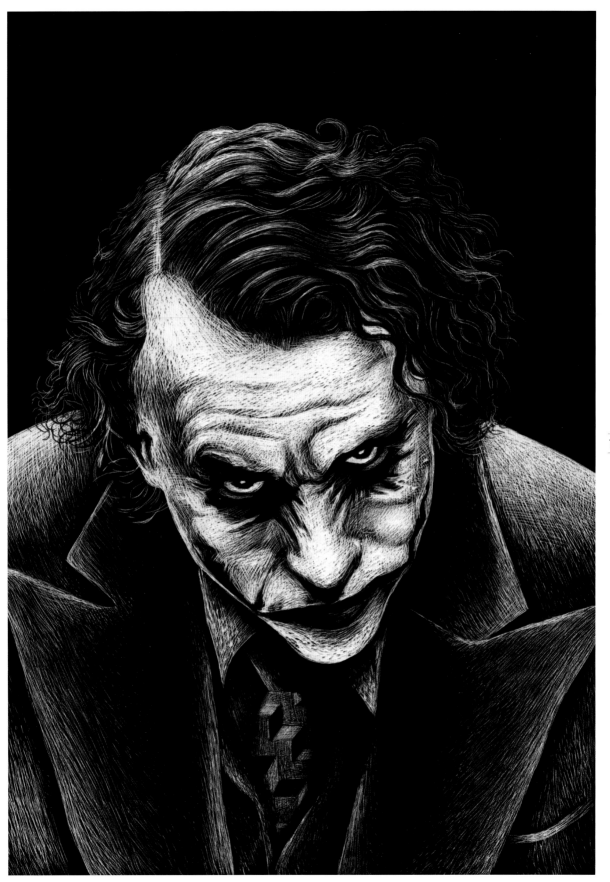

We can do frottage on any type of surface, whether organic or synthetic.

Frottage can be produced with graphite pencil, charcoal, wax or any material that is capable of capturing the texture of the object underneath the paper.

8.2
Frottage

This technique, as I have already explained above, consists in reproducing the textures of different objects, and in many cases it yields amazing results. As we can see in the examples, textures produced either from natural or synthetic objects are always very attractive and surprising.

Not only simple textures
Artists such as *Max Ernst*, who developed this technique, created complex works (figurative or abstract ones) by overlaying and interrelating various textures.

The frottage technique can prove to be very enriching on a creative level, since it allows us to experiment and combine textures to achieve results of great artistic value.

Method
For this example, I cut the profile of an elderly woman into a piece of masking card to create a protective mask for the background. For the rest of the picture, I have superposed textures from a variety of sources to achieve an abstract composition in which, thanks to the protected area, a silhouette of the woman can be made out.

To produce frottage in this style, we should choose objects whose textures we find attractive, or surfaces with a certain amount of relief.

In each case, we will place a sheet of 80 g paper over the object or surface chosen and, with a wooden 7B, pencil and a bar of graphite or charcoal, we will rub the paper while applying light pressure, so that the texture of the object becomes stamped on the paper.

If, as in the example illustration, we are also creating superposed textures, we will obtain a more complex work with more character.

The frottage technique can prove to be very
enriching on a creative level, since it allows us to
experiment and combine textures to achieve results
of great artistic value.

Topic 9

PRINTMAKING

Print ma king

Linography, xylography, lithography and serigraphy are some of the commonest black and white print techniques.

A LITTLE HISTORY

The first people to reproduce originals in series were the Sumerians in Mesopotamia three thousand years ago. They carved drawings on polished cylindrical stones that they then rolled on a soft clay, thus "printing" an image of the original drawing.

The first printing press

Later, in China, after the invention of paper, the first paper reproductions created using stone emerged.

In Japan, prints reached their peak between the seventeenth and twentieth centuries, with landscape and theatrical pieces made using the *Ukiyo-e* technique.

In Europe, the first prints date from the sixth century, with the technique being used in particular in the textile industry. The first paper reproductions were made in Spain around the twelfth century. Later, at the beginning of the

The first people to reproduce originals in series were the Sumerians in Mesopotamia three thousand years ago. They carved drawings on polished cylindrical stones that they then rolled on a soft clay.

fifteenth century, cards featuring woodcut printing were made in Germany, and shortly after the first stamps appeared in England.

But it was during the Renaissance that printmaking became more frequent.

What is it?
Printmaking is an artistic discipline that entails drawing with a sharp item on a hard surface called a "matrix" (which can be made of stone, wood, plastic, linoleum or metal), to which ink is then applied. The ink is then transferred by placing pressure on the matrix against another surface such as paper or cloth, among others. Through the process, multiple copies of the same design can be produced.

There are many printmaking techniques, but some of the commonest are the following:

Linography
Linoleum is used for the matrix.

Woodcut
Wood is used for the matrix.

Lithography
Limestone is used for the matrix.

Screen printing
Consists of transferring the image to be printed through a mesh called a screen. ∎

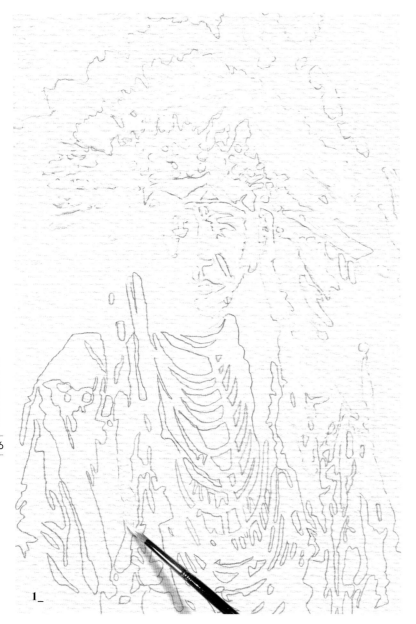

1_

As India ink is indelible, it only cracks and falls off the support medium when it has adhered to white gouache; the rest of the ink remains printed on the paper.

_The tone of the paper

For this type of illustration, it is important to choose an off-white watercolour paper. If we do so, it will be easier to apply white gouache, because we will have a difference in tone between the painting and the background, and we will be able to see where we have applied the paint and where we have not.

9.1
"Fake" printmaking

The iconic image of Chief Duck

To implement this technique, I have worked based on old photos of *Chief Duck*, a nineteenth-century American Indian chief, the leader of the *Blackfoot* tribe. This image, laden with solemnity and character, boasts artistic values that will be useful to us in creating a fake print: it features a high contrast between black and white, great graphical force and historical value. (👁 See page 58)

Control isn't everything

A fake black and white print is very expressive and relatively easy to make. It is not a real print; we're just looking to simulate one's aesthetic finish and not its reproduction process.

This is not an ideal method for producing details, because we cannot predict the outcome after wetting the paper, but this is why I think it's a very stimulating technique: the end result is not completely under our control. So this is an experiment that will allow us to enjoy working with our hands and with a certain element of surprise.

2_

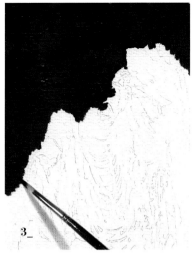

3_

4_

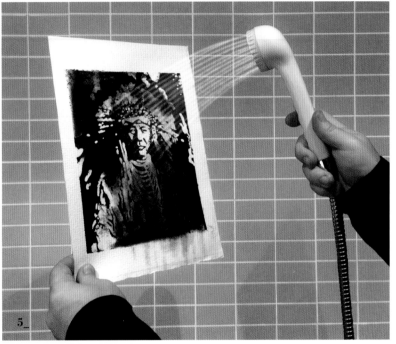

5_

It is important to work on a heavy paper, since when the time comes to clean off the ink with water, the paper will curl less and the excess ink will disappear more easily.

Method

1_ We will draw the portrait with the help of old photos. We then gently trace it onto off-white, fine-grain 350 g watercolour paper.

1+2_ Using a no. 2 brush, we begin to paint the light parts of the image with a very thick white gouache. We don't paint the parts that we want to be black.

2_ Once the white areas have been painted, let the gouache dry completely, which should take about half an hour.

3+4_ We cover the entire surface with India ink using a no. 12 brush, without pressing on the paper much so as not to pull away any gouache, but covering it completely and without worrying.

5_ When the India ink is completely dry (approximately half an hour after you apply it), we will remove the masking tape and sprinkle water over all the paper with a medium to strong level of pressure to rescue the whites of the image. A good place to perform this operation is the shower, as we will be able to play with the pressure and the amount of water needed.

Method

6_ We will leave our "print" to dry, if possible in a vertical position to get rid of all of the water, using pegs to hang it.

Last step_ Given that India ink is indelible, it will only crack and peel off the paper where it was affixed to the white gouache. This approach gives us an imperfect effect that is full of sweeping and "aged" textures and evokes the artisanal reproduction of an authentic print.

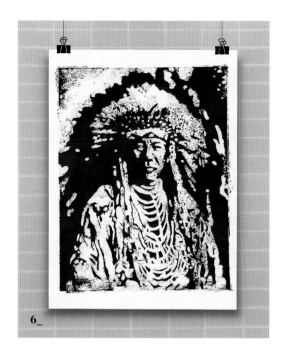

6_

The more we tauten the paper at the time of drying, the flatter our final illustration will be.

Craquelure

Surprisingly, this technique will often create the magnificent texture known as "craquelure," which is the result of the surface of paintings cracking. This effect is common in old paintings and canvases that have not been handled correctly in terms of temperature and environmental conditions, and it is very attractive because it gives illustrations an antique and artisanal look.

_M. C. Escher
This Dutch artist , who is difficult to classify in terms of style, was a master of trompe l'oeil and optical illusions, and he made over four hundred lithographs and woodcuts.

There are hundreds and even thousands of reproductions of many of them, in spite of the fact that at the end of his career the artist destroyed some of the plates so that there would be no more copies of his designs.
www.mcescher.com

It is not a real print; we're just looking to simulate one's aesthetic finish and not its reproduction process.

1_

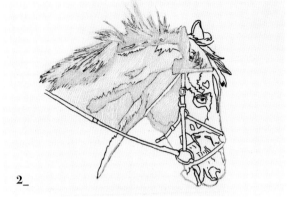

2_

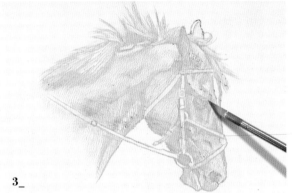

3_

4_

9.2
Printmaking with an acetate-paper matrix

A "homemade" method of printmaking

As I mentioned earlier, to create a print we need a matrix to etch our illustration onto, and based on that matrix we will be able to replicate our image.

In this case, the surface on which we will draw—that is, the matrix—will be an acetate sheet. This will enable us, in a very rudimentary fashion, to produce an unlimited number of copies of our drawing.

The energetic head of a horse in motion will allow us to understand this interesting technique.

Method

When drawing, we must also take into account that, in the final print, the position of the horse's head will be inverted.

1_ Once we have the finished drawing, we will trace it on a 4 mm -thick acetate sheet with a permanent black marker.

2+3_ We will begin to draw, or rather scrape, hatching to produce the profile and the volumes of the horse, gently massaging the acetate with a scalpel and exerting strong pressure to create grooves of a certain depth. (👁 See pages 31 and 97)

The depth of the groove on the acetate sheet will depend on the force that we exert and the sharpness of the scalpel's tip.

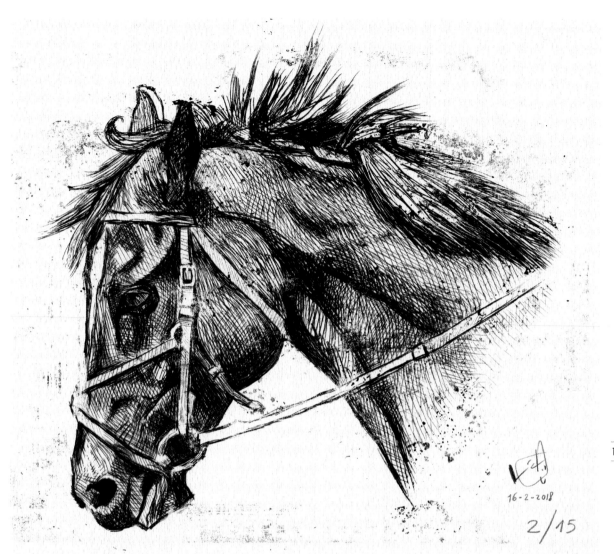

16-2-2018

2/15

4_ Once the hatching for the horse has been completed, we will spread a coat of black oil paint over the acetate sheet, fully covering the drawing.

Using a silk paper, we will press down on the paint so that it gets fully into all the grooves, and we will clean the outer surface of the acetate using the same type of paper and without applying too much pressure.

5_ We then place a sheet of smooth 120 g drawing paper over the acetate sheet and, once the edges of the paper are held in place so that the paper does not move, we will press hard with a roller, a folding tool or a spoon, so that the ink in the furrows of the acetate will impregnate the paper as much as possible.

We flip the paper, and voilà! Our print is finished.

Last step_ If we repeat the action with fresh watercolour paper and replenish the black paint, we will be able to create an unlimited number of copies of our print.

If you prefer to create a limited series such as a set of artistic prints, you can number them.

_Acetate paper
as a basis for a final drawing
If you fancy experimenting, you can also use acetate paper as a base, scraping its surface in a grattage style; you'll see that the result is very interesting, because what you will create is a subtle and very unusual drawing. (◉ See Figure 3)

Mixed media

Use of mixed media is a widespread artistic technique nowadays, and one turned to by many contemporary artists.

A LITTLE HISTORY

By definition, mixed-media art is any form of art that combines two or more media in one work. The use of the term began in the early twentieth century with the cubist collages of *Pablo Picasso* and *Georges Braque*.

First efforts

Although they are not considered to be mixed-media artists, the artists of the Byzantine Empire (from 330 to 1453 CE) often used gold leaf in their paintings, mosaics, frescoes and manuscripts. In the Renaissance, oil painting became very popular, and many artists also applied gold leaf to wooden religious panels painted with oils or tempera to make the heavens brighter.

The first mixed-media artwork

Pablo Picasso and *Georges Braque*, considered to be the fathers of cubism, broke with centuries of

The possibilities offered by this technique are endless, and they depend only on the artist's imagination and experimentation.

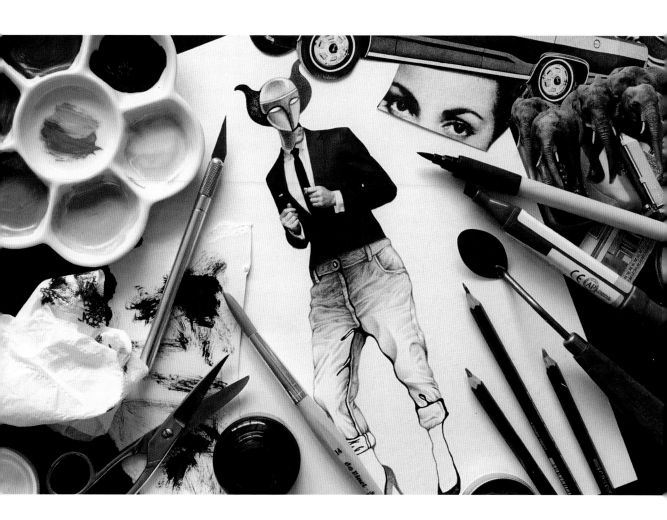

traditional painting by depicting objects as three-dimensional images that could be painted from multiple points of view.

But their explorations of new methods for artistic expression went much further than that. In 1912, *Picasso* created the first mixed-media piece, *Naturaleza muerta con silla de rejilla*, in which he combined on the same canvas paper, a piece of

oilcloth (whose pattern simulates the braiding of the chair seat's wickerwork) and oils.

In the twenty-first century
Use of mixed media is a widespread artistic technique nowadays, and one turned to by many contemporary artists. We can say that anything now goes when it comes to creating. The unimaginable can be shamelessly combined.

Assemblages or collages may, on any support medium, mix acrylics, watercolours, oils, graphite, digital images, metals, fabrics, prints, rubber stamps, sculptures, torn paper, inks and objects of all kinds and origins.

The possibilities offered by this technique are endless, and they depend only on the artist's experimentation. ∎

1_

2_

3_

1 Collage

2 Marker

3 Pencil

10
Mixed media: Collage, pencil, marker and hatching

Superheroine
To develop an example of a mixed-media work, I created a superheroine who is herself a hybrid, taking my inspiration from the legendary 1980s series *Mazinger Z*.

The idea was to create a new *Aphrodite A* seen through the eyes of *Baron Ashura*, a fun excuse for mixing together several artistic techniques. I opted for collage, marker and pencil, and to finish things off, I set everything against digitally generated dotted hatching.

Method

1_ Collage
Find and cut out a black and white photo that gives you inspiration. In my case, I have used one of the torso of a model dressed in a suit and tie, which I found in an avant-garde magazine.

Glue the picture on special 300 g paper for pencil with a very fine grain.

2_ Based on the photo you found, use a pencil to give shape to your superheroine, rendering the head and legs.

2+3_ Marker
Trace and mark out the areas that you want to depict with a marker.

3_ Pencil
Here, I work on the face of *Aphrodite A* and the inside of the jeans with three pencils of different hardnesses (2H, B and 2B).

Last step_ Digital finish
Once the figure has been finished, we will scan the original and apply halftone gradation hatching for the background, which we'll produce in Photoshop.

_Ruth Morán
This Spanish artist produces abstract compositions in white on black, a result of the use of different procedures, from vinyl tempera and marker to structures created with perforated papers. Her work has evolved from the use of tangled linear hatching with a textile appearance to more ordered geometric constructions.

Appendix

Beyond paper

Bird's eye view

In this special section, I will present a selection of possible applications for a black and white illustration. You will see that with a simple marker stroke we can achieve amazing results. I have worked with a bird's-eye image of a group of people strolling through a broad avenue of a typical city. The original illustration, produced with two thicknesses of marker (👁 see page 38), was devised with

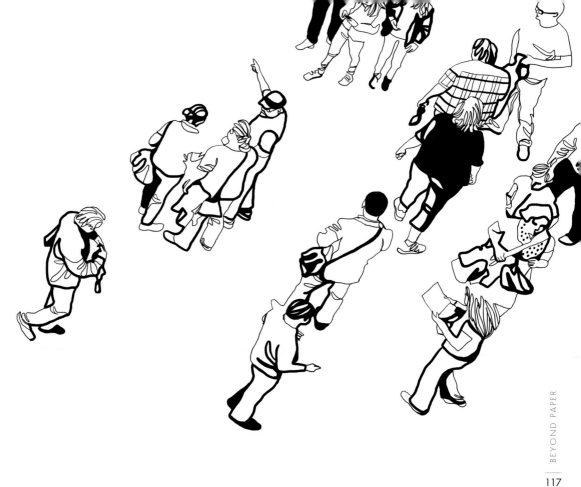

an open-ended structure to allow it to have multiple applications, whether we use part or all of it. This means we can create, depending on the application, an iconic image of a single character or, by contrast, a kind of pattern of figures.

Black and white and vice versa
I have to stress that all the applications that we will explore in this section could be applied in reverse relative to the description given in the examples—that is, negatives could be positive and vice versa. Nowadays, all paints, markers and inks can be found in both black and white. ∎

A motif or pattern is an image that, when positioned next to itself repeatedly, can be infinitely extended without interrupting the drawing. Patterns and motifs can be of very varied types.

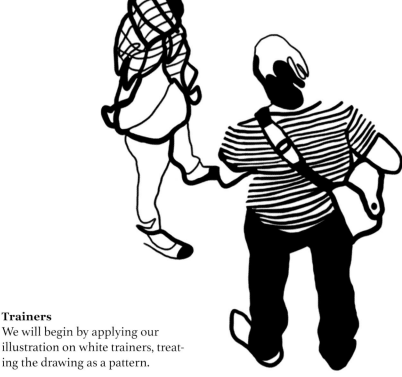

A.1
Applications on textiles

Is anyone else who loves to draw fed up with the fashions that are imposed on us? Well, the time has come to create new trends of our own, and we can do this by applying our own black and white illustrations and customizing anything that we pull out of our wardrobe. The following examples are just the tip of the iceberg. An idea can be applied to trousers, hats, socks, scarves, jackets, underwear... whatever suits you.

Trainers
We will begin by applying our illustration on white trainers, treating the drawing as a pattern.

Materials that we could use
◆ Permanent black marker for fabric.
◆ Permanent black paint for fabric.

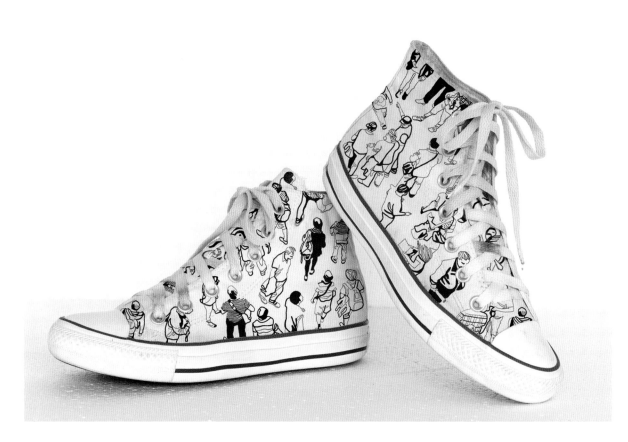

The time has come to create new trends of our own, and we can do this by applying our own illustrations and customizing anything that we pull out of our wardrobe.

T-shirt

T-shirts are always a good garment to customize. In this case, we will design the t-shirt with fewer figures and apply them in a larger size.
We could illustrate both the front and rear, since if we are painting by hand, there are no limits.

Materials that we could use

- Permanent white marker for fabric.
- Permanent white paint for fabric.
- Commercial silk screen printing.

Cotton bag

Nowadays it is possible to customize cotton bags of this type by having your picture applied by a printing company. But generally speaking, with this option you will have a limited area to place your design in, as is also the case, for example, with t-shirts.
If, by contrast, you paint your drawing directly on the bag by hand, not only will you create a unique piece, but the support medium will offer much more freedom, as you will be able to use its entire surface.

Materials that we could use

- Permanent black marker for fabric.
- Permanent black paint for fabric.
- Commercial silk screen printing.

For decorative applications, you can also turn to services that allow you to customize any type of fabric, as well as wallpapers, cushions and so on, with your own designs. For example: **www.spoonflower.com**

Black and white décor is a classic and is adaptable to all styles, from the most avant-garde to the most traditional. Its style and elegance will never go out of fashion.

A.2
Decorative applications

Black and white décor is a classic and is adaptable to all styles, from the most avant-garde to the most traditional. Its style, functionalism and elegance will never go out of fashion.

Unlike with other colours, the minimalism of black and white lends personality to our compositions, and at the same time it will give a space a free and easy feel, with its achromatism neutralizing and unifying the tones of the objects that share the same visual space with it.

Shower curtains
Applying our design on any surface in our own home can be a very stimulating exercise. We might try, for example, painting our character pattern by hand on a boring white curtain that we bought some years ago.

Materials that we could use
◆ Permanent and water-resistant black marker pen for plastic or cloth.
◆ Black and water-resistant acrylic paint for plastic or cloth.

Walls
Our illustrations can also be applied to a wall, decorating our most personal spaces in a unique way. If you do the drawing by hand, you will have to set it on a grid to resize its proportions in a precise manner. (👁 See page 123)

Materials that we could use
◆ Special black marker for walls.
◆ Black paint for walls.
◆ Specially cut vinyl for walls (highly recommended for these applications).

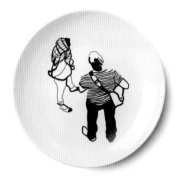
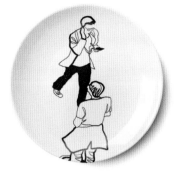

Crockery

Decorating your own set of plates or cups with motifs is a lot of fun. All you need to do it is a permanent marker (or paint) for porcelain. If the decorated plates are for use with food, make sure that the paints used are not toxic. You can also put patterns on ceramics through commercial silk screen printing.

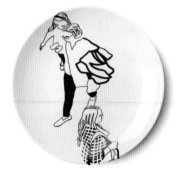
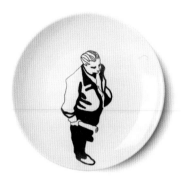

A.3
Applications to glass

Window glass

Another support medium that is worth appreciating and that offers a lot of play when decorating is glass. In the picture, you will see our characters applied in white to the windows of a restaurant. In this case, it is important to resize our design using a grid, so that when it is enlarged it is fully proportionate and accurate.

Materials that we could use

- Special white marker (or paint) for glass.
- Specially cut vinyl for glass (highly recommended for these applications).

_Special markers

With special markers for painting on glass, you can also decorate bottles, cups and so on, provided that you either don't let the painted surface come into contact with the drink or ensure that the medium is not toxic.

Grids

A grid will let us easily resize images to scale, which allows us to reproduce a small drawing in a larger area, preserving the characteristics and proportions and not distorting or altering them.

A 4
Exterior applications

Decorating the external blinds of a business or the door of your own garage is another way to apply our illustration. Although the support medium is very inconsistent, the end result is usually very striking, mainly due to the dimensions.

Materials that we could use
- Special acrylic paint for aluminium.
- Special spray paint for aluminium (freehand, or with stencils or masking).

Spray paint requires some practice. However, it is the most convenient medium for working on support media of this type.

Ten final tips to keep you exploring

In this final section, I offer up, in very brief form, **ten final tips** so that you can continue investigating new forms of creation beyond this book.

1_ Pouring salt on a patch of ink will add organic textures to your drawing.

2_ We can blow through an disposable ballpoint pen to create a "homemade" airbrush, which will give us spray textures.

3_ A sharp razor blade allows us to rectify or erase ink strokes.

4_ With just a toothpick dipped in gouache, you will be able to create expressive and varied strokes.

5_ Your own fingerprints can be used to create new hatching in your pictures.

6_ Sponges and cloths are always essential when it comes to creating new textures.

7_ You can use a hairdryer when drawing to direct the ink or watercolour on the paper.

8_ If we flick the bristles of an old toothbrush after dipping them in ink, we will achieve interesting pointillist spots.

9_ By profiling a precise area with masking tape and a cloth wet in any oil paint, we can create very interesting textures and shapes.

10_ To blend graphite or charcoal, you can use a cotton bud from your medicine cabinet.

A toothpick dipped in gouache will provide us with more expressive strokes, and a disposable ballpoint pen will work as a homemade airbrush, adding new textures to our illustrations.

Acknowledgements

I am are grateful to all the makers
of the brands of professional tools
and products that appear in the
book, as without them our creations
would not be possible.

I would also like to thank the
photographers who, with their
images, have been a source of
inspiration in the creation of some of
the illustrations in this book.

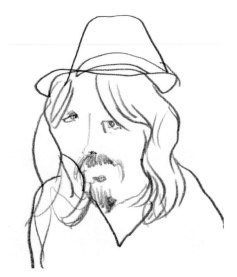

*Portrait of Victor Escandell made by the artist Martí
Cormand in pencil and with his eyes closed.*
(👁 See page 37)

Víctor Escandell

Born in Ibiza, Victor Escandell currently lives and works in
both Barcelona and Madrid. He is an artist who advocates a
"multistyle" approach as another form of creativity. During his
long career, he has worked with Spain's leading newspapers. He
has also worked with many international advertising agencies.
Within the publishing world, thanks to the variety of styles in
which he works, he has published a large number of illustrated
books, for both child and adult audiences. His works have won
various renowned illustration awards.

www.victorescandell.com